Oil Painting
Outdoors

JOHN C. PELLEW, N.A., A.W.S.

Oil Painting Outdoors

WATSON-GUPTILL PUBLICATIONS, NEW YORK

PITMAN PUBLISHING, LONDON

First Published 1971 in New York by Watson-Guptill Publications
a division of Billboard Publications, Inc.
One Astor Plaza, New York, N.Y. 10036

Manufactured in Japan

ISBN 0-8230-3283-3

Library of Congress Catalog Card Number: 70-150143

Hardbound Edition
 First Printing, 1971
Paperback Edition
 First Printing, 1976

Paperback edition also published in Great Britain 1976 by Sir Isaac Pitman & Sons Ltd.
39 Parker Street, Kingsway, London WC2B 5PB
ISBN 0-273-00240-6

For Elma with love

Color plates

Contents

Introduction

Oil or watercolor, which is the better medium? Specialists in one scorn the other. The old argument goes on—and I suppose it will continue as long as there are painters around to talk shop. It's all rather pointless because the two media really aren't—or shouldn't be—in competition. Since I believe that a painter who specializes in one medium misses half the delight of being an artist, I've worked in both media for many years. I've had successes and failures in both oil and water-color—but it's been fun.

I painted my first outdoor oil sketch forty years ago, and I've been at it ever since. I've never tried to reckon the total I've painted, but it must be well over a thousand. Surely *nobody* could go to nature that often (as I hope you'll do) and come back without some knowledge of landscape. For this reason, the major portion of this book is devoted to painting landscape sketches or impressions directly from nature.

Since watercolor is the more difficult medium, I advise the inexperienced landscapist to start with oil. Of course it's messier. But it's also easier to control and correct. I can see the watercolor specialists nodding their heads when I admit that their medium is the more difficult. However, before they get too puffed with pride, I hasten to remind them that many of the world's best watercolors were painted by oil painters. "Name some," they say. Well, how about Turner for a start? Then there's Whistler and John Singer Sargent—and don't forget Winslow Homer.

Here, then, is a book for those who want to experience the thrill of setting up their easel in the country or along the shore—the same thrill or feeling of excitement that must have gripped the great landscape painters who preceded us: Constable, Corot, Monet, and my special favorite, Eugene Boudin, to name just a few.

Landscape painting has been my life, my "thing," since I first saw painters working outdoors in my native Cornwall. If I can bring something of what I've learned along the way to those who want to set down in oil paint some personal impressions of the beauty found in nature, then I'll feel that I've accomplished a great deal—and I'll be happy.

Norwalk, Connecticut

Oil Painting
Outdoors

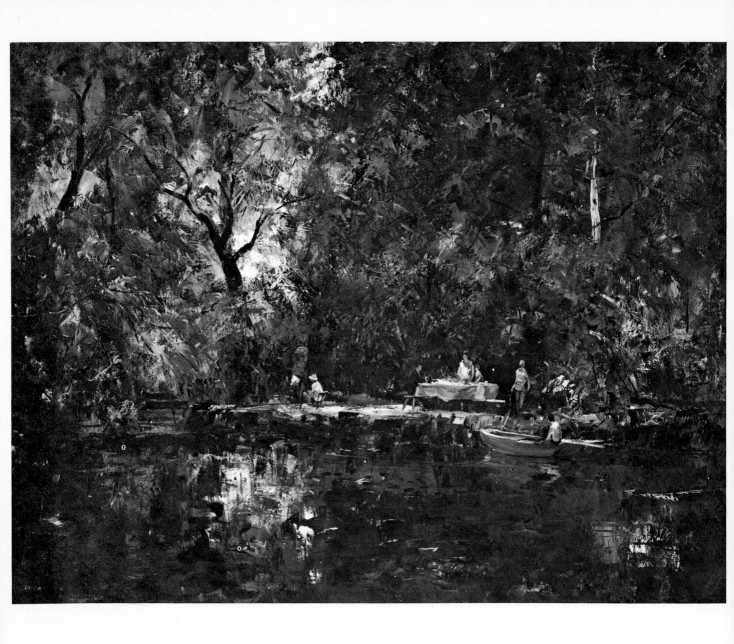

SUMMERTIME, oil on canvas, 30″ x 40″.

"Summertime and the livin' is easy." That's what George Gershwin's famous song tells us and that's just the feeling I'm trying to convey to the viewer in this painting. I must have reached the awards jury of the 1968 Allied Artists of America exhibition in New York, because they gave it a medal. This is a studio painting; it's also a memory painting. I suppose it grew out of memories of several small sketches painted at the Mill Pond in Rockport. Being done as it was without reference to previous sketches, it's not a portrait of the place. There are two influences at work here. First, the lush summer foliage with its thick, rich impasto plus the painting's low key combine to suggest Constable. The figures in gay, colorful clothing and the flickering sun breaking through the trees, splashing the people with spots of golden light, surely bring Boudin and the impressionists to mind. Well, if you're going to have influences can you think of any better two? Except for the figures, boat, and treetrunks, the entire picture was painted with the palette knife, dragging light paint over dark and dark over light, until the desired effect was obtained.

Some masters of landscape

LANDSCAPE PAINTING is a northern art. The Latins are figure painters. With few exceptions, the great landscape painters have been English, French, Dutch, and in recent times, artists of North America. I don't know why this should be unless, perhaps, the cooler climate of the northern countries has something to do with it. I'd rather think it's the northerners' love of nature. The English, in particular, are known to be great nature lovers. The "country walk" is an English institution and every Englishman (and woman) is a gardener at heart, if not in reality.

I'm sure that England has produced more landscape art than any other country. For that reason alone, it seems a good place to start my brief survey of the background of outdoor landscape painting—really a survey of some masters to learn from. Of course, landscapes have been painted ever since painting began; but the theme of this book deals with the art of painting from nature, so I shall hurry on to the men who first carried their easels into the fields and worked directly from the subject before them. However, let's first take a quick look at the kind of landscape being done just *before* this historic event took place. These early landscapes were studio productions painted from black and white drawings—and sometimes parts of these landscapes were even stolen from engravings by earlier artists.

Gainsborough

Thomas Gainsborough (1727–1788), though best known for his portraits of the English gentry, was one of the first Englishmen to become interested in landscape as an art in itself. He didn't paint outdoors. It's said that he made on-the-spot landscape sketches in chalk from which he painted in the studio. He also had a special table upon which he constructed model landscapes, using bits of dried plants, twigs, stones, and even pieces of broken mirror. Transferred to canvas in the medium of oil paint, these still life setups became romantic, picturesque landscapes.

There were other painters, some before and some after Gainsborough, who painted in the picturesque landscape tradition. They were fond of compositions that featured a ruin, a castle, or a bridge with a broken arch. These pictures, with their theatrical approach to nature and their drab color, have little appeal today for anyone but the art historian. Let's not linger with these painters, some of whom were good artists, but let's get out into the sunlight and the world beyond the studio walls.

Constable

That brings us, of course, to John Constable (1776–1837), who once wrote in a letter to a friend, "There is room for a natural painter." By that, I take it, he meant a painter who'd paint nature as it really was and not as it appeared on the canvases of the purveyors of picturesque romanticism. It's on record that while visiting the country estate of a wealthy collector, Constable placed a violin on the lawn in order to prove that grass was green, really green, not the conventional greenish brown favored by the landscape painters of that day. No doubt his host was astonished. Artists have always taught their fellow men to *see*.

John Constable took his paintbox and easel into the fields of his native Suffolk and painted on the banks of the river Stour, where his father owned and operated Flatford Mill. The oil sketches he made there were small; 7″ × 9″ seems to have been a favorite size. Many of them were painted on paper, an excellent surface for sketches in oil. I'll comment on this in the next chapter. In these small sketches, Constable did something that hadn't been done before. He used oil paint to capture the illusion of nature's flickering light. He painted clouds that moved across the sky, trees that would bend in the wind, and water that caught and reflected sunlight as it flowed between the banks of his beloved river Stour.

Whether you first see these little landscapes "in the flesh" at the Victoria & Albert Museum in London or in reproductions, remember that they're much more than interesting sketches of English countryside by a talented painter. They were the first of their kind; they were the eye openers. They led the way to impressionism. They were the first direct statements from nature, and didn't pretend to be anything else. The Constable country hasn't changed much. Flatford Mill is still there, and you can visit the cottage that appears in the world famous painting known as *The Hay Wain*. It's also seen in *Willy Lott's House,* another Constable masterpiece. When I was there a few years ago, I felt that I was walking through pictures I'd known since I was a boy.

I can't agree with the English critic R. H. Wilenski that Constable has nothing to offer the student of today. Perhaps nothing for the nonobjective painter, the hard edge, or the pop artist, but certainly a great deal for the serious student of natural landscape. When talking to art classes or even to many of my professional colleagues, I'm constantly amazed at how little they know of the history of the branch of art they profess to be profoundly interested in.

Constable's sketches deserve the attention of every student of landscape painting. His work had a great influence on the French painters. *The Hay Wain* made a tremendous impression when it was exhibited at the Paris Salon of 1824. It's said that after viewing Constable's picture, Delacroix repainted the background of his own canvas in that same exhibition.

The Barbizon school

Now let's take a look at that important group of French landscape painters known as the Barbizon school. The work of the Barbizon painters in France is the bridge between romanticism and impressionism. For that reason, it's worthy of our attention. It's also important to the readers of this book because one of its members, Charles François Daubigny (1817–1878), was probably the first to complete a picture in the open air. True, some critics of the period called his pictures "sketches." Today we see them as beautiful works of art by a great landscape painter. He often worked from a houseboat studio along the banks of the river Oise. My favorite among that talented group of landscapists, Daubigny is known to have influenced Claude Monet (1840–1926).

Besides Daubigny, the other important Barbizon men were Theodore Rousseau (1812–1867), Jean François Millet (1814–1875), Jules Dupré (1811–1889), and Narcisse Diaz (1807–1876). Camille Corot (1796–1875) is sometimes thought of as a member of the group. However, he'd been painting in the Forest of Fontainebleau before the others arrived there.

Except for Daubigny and Corot, the works of these painters seem rather theatrical to us today. Just the same, it will do the student of landscape no harm to look at them when visiting museums.

The plein air movement

The next (and quite important) event in the history of outdoor painting was the so-called *plein air* movement, which influenced both landscape and figure painters in France, England, and America. The French painter Bastien Lepage was the leader of this group, who were mainly figure painters. However, they broke with tradition—studio tradition—and posed their models outdoors. The settings in which the models posed are often quite beautiful—so well painted that they're fascinating to the student of landscape.

The only Lepage I've seen in America is his *Vision of Saint Joan* in New York's Metropolitan Museum of Art. If you disregard the symbolism, it's really a picture of a peasant girl in an overgrown Normandy garden. The foreground contains some of the most marvelous weed painting I've ever seen. It's also a magnificent rendering of outdoor light.

The painters of this school put the study of tonal values before all else. Mix the correct value; put it down; and avoid destroying it with overworking. This is a good method for the landscape sketcher because it's the correct tonal value relationship that creates the illusion of reality—not the finicky details. I comment on the importance of value study in a later chapter.

Impressionism

The next great landscape school is impressionism. Many books have been written, explaining the theory behind the method used by the impressionist painters. I don't think the student need concern himself with the study of optics. Thousands of good landscape painters have painted in the manner of the impressionists without knowing anything about the complex theory that Claude Monet supposedly worked out. In his old age, it's said he denied that there ever was any such theory. In my opinion, if Monet hadn't gone to London to escape military service during the Franco-Prussian war—where he first saw Turner's late work —and, if he hadn't suffered from astigmatism all his life, he might never have painted impressionist pictures. But he did, and we're glad that he did.

Impressionism is an art of the eye. The mind and the memory play no part in this purely visual approach to painting. It's a snapshot art. The compositions of most impressionists are often what you get when you point a camera at nature. Their concern was with light and they believed that they had a better method than the followers of Bastien Lepage, their direct contemporaries. The impressionists painted in broken color or divided color. For instance, touches of blue and yellow were placed side by side to produce green when viewed from the normal picture-viewing distance. This sets up a color vibration which was thought to be closer to the effects of natural light. At least that was the theory. But none of them really adhered to it.

It would take more space than I'm allotted to explain the aims and purposes of all the different schools of landscape painting. I can only point the way to

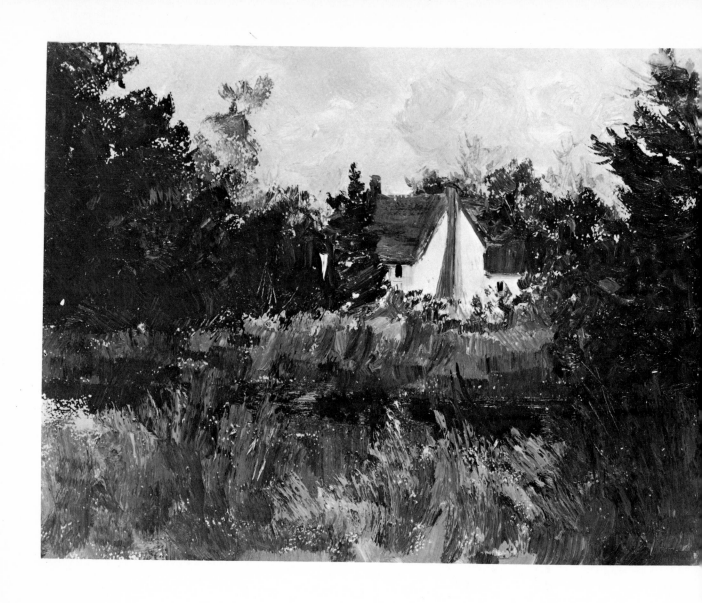

WILLY LOTT'S HOUSE, oil on gesso panel, 9" x 12".

As any student of John Constable knows, the above title is also the title of one of that master's greatest works. The cottage in my painting is also the cottage seen in Constable's famous painting The Hay Wain *done in 1821. It's still there on the banks of the little river Stour in Suffolk, England. Willy Lott has long since departed, having died in 1849 in his eighty-eighth year, but he was living in this house when his friend Constable painted it. In fact, he lived there all of his long life. I wonder what he would have said if he'd known that his humble farm cottage would become world famous because John Constable, the artist, had put it in a*

picture. It thrilled me to visit the place. After lunch in the garden of a charming riverside inn, I strolled along the path that follows the curving banks of the Stour. I soon came to the cottage and sat down to sketch it. Flatford Mill, once owned by Constable's father, was also in sight, but as the bus was returning to London in an hour there was only time for one sketch. Here it is—a fast one with plenty of rich, thick paint put down at top speed. I'll admit I worked in kind of a glow. Painting in the place where the great John Constable painted 150 years ago does something to you.

avenues of study that I feel will benefit the student of outdoor painting. In a later chapter I tell what I think an impression from nature is and how it should be handled.

Four Americans

The Americans who interest me—and in some cases influenced me—are Winslow Homer (1836–1910) and John Singer Sargent (1856–1925). Both men, particularly Sargent, are as well known for their figure work as for their landscapes. However, they did a great deal of on-the-spot painting in both oil and watercolor. They're well represented in museums and books. I urge all landscape students to study the work of these two important Americans.

There are two other painters who had a great influence on my early work: George Bellows (1882–1925) and Edward Hopper (1882–1967). For boldness and vigor, the oil sketches Bellows painted on the Maine islands are hard to beat. There's less thunder and lightning in the New England landscapes of Edward Hopper, but nevertheless, they're powerful statements by a great painter.

This, then, is my brief look at some masters of outdoor painting. Much has been written on most of these artists and the serious student will not only have an enjoyable time, but will learn a lot by spending some winter evenings reading about them. Be well informed; learn as much as you can of your craft and the painters who've worked in it.

At the end of this book, there's a list of books that I've read on the subject. Time well spent, too.

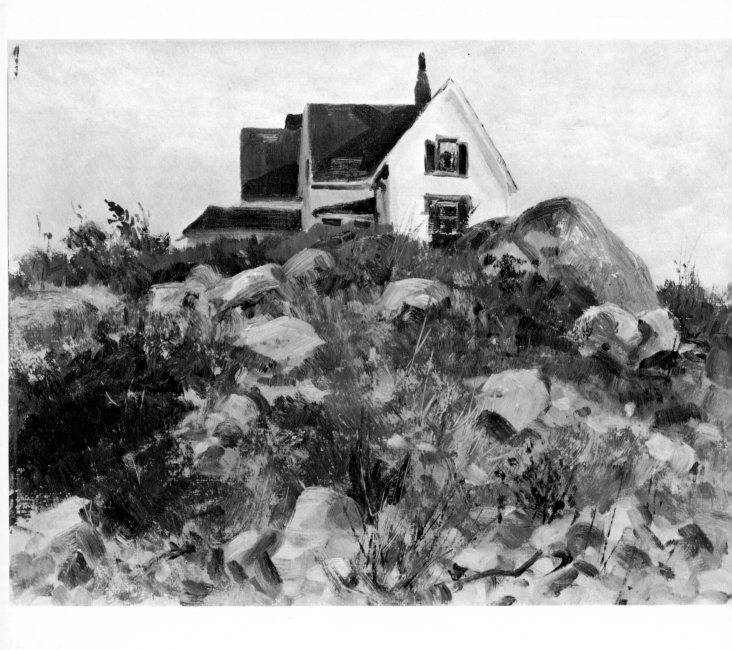

THE LIGHTKEEPER'S HOUSE, oil on gesso panel, 12" x 16".

I'm fond of saying that nature seldom presents us with a ready-made composition. I certainly carried out my own advice when I painted this sketch at Eastern Point, Gloucester, Massachusetts. Standing where I did, the lighthouse was in plain view at the right of the house. The lighthouse and the keeper's house were entirely surrounded by a tall, steel wire fence. I soon decided not to see the fence. There was a reason for it being there—this was government property—but I couldn't let it ruin my composition. My next move was a daring piece of *simplification. I decided to ignore the lighthouse. Ever try to ignore a lighthouse? It isn't easy. I was beginning to get a little tired of lighthouse pictures, so out it went. It was the keeper's dwelling with the rocky foreground that first attracted me. I'm also fond of telling my students to never hesitate in taking liberties with nature if their composition can be improved by so doing. I was again following my own advice with this painting. I rather like the title which wouldn't have been as effective if I had included the lighthouse.*

Tools of the trade

THERE ARE some pieces of equipment that are absolutely necessary for outdoor painting, things that you just can't get along without. There are also a great many unnecessary gadgets on the market. Unfortunately, the beginner gets trapped into buying them and ends by setting out with far too much heavy, uncomfortable junk. Except for an easel—which is a must—all the rest of your equipment should go into the paintbox. That makes just two things to carry. More than that becomes a nuisance.

Easels

The best kind of easel is one that can be set up or taken down quickly. There's nothing more exasperating than a balky easel when you're presented with an exciting, but fleeting, effect in nature. That's when you need to get at the canvas or panel in a hurry. There's no time to fool around with a set of sticks that fold and unfold every-which-way or with wing nuts that fall into the grass and have to be searched for on hands and knees. We landscape painters are simple folk and we need simple equipment, the kind that allows us to get to the all-important business of painting as soon as possible.

I think the Anderson easel (Figure 1) meets all the requirements. I've used one for many years. Its legs are self-locking and there are no screws to get lost. Some painters like the French combination box and easel. It is *good*, and those I've examined are very well made. However, for my taste, they have too many folding parts, plus nuts and bolts. Fiddling with contraptions of this kind—when insects are biting, the wind's blowing, or it's starting to rain—I find annoying as the devil, to say the least!

There are also some very lightweight aluminum easels being sold. Those I've seen are so light that even a gentle breeze would tip them; any stronger wind would blow them over. Take my advice and get a strong, sturdy easel, one that stays put under all conditions.

The pegs supplied with the Anderson easel are designed for canvases to rest upon. I find them rather large and they get in the way when small panels are used. A couple of 3/8″ dowels, each 2″ long, work well and fit in the paintbox.

Paintbox

My father made the first box I carried on my early painting expeditions. I made a pencil sketch of one I saw displayed in an art supply store window, and

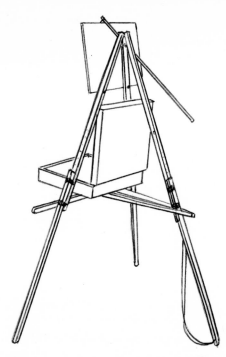

Figure 1 *The old reliable, the Anderson easel, is sometimes called the Gloucester easel.*

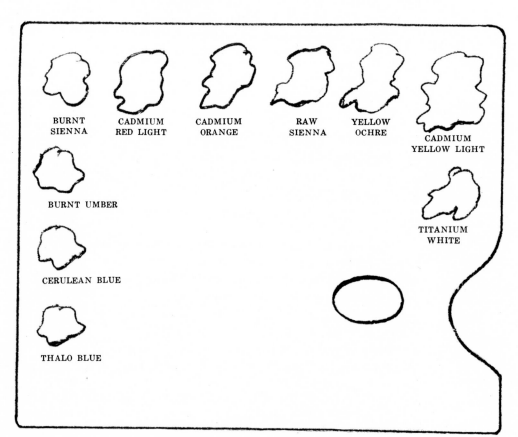

BURNT
SIENNA

CADMIUM
RED LIGHT

CADMIUM
ORANGE

RAW
SIENNA

YELLOW
OCHRE

CADMIUM
YELLOW LIGHT

BURNT UMBER

TITANIUM
WHITE

CERULEAN BLUE

THALO BLUE

Figure 2 *Here's my palette set for outdoor sketching. If you count white as a color, there are ten. I place the lightest colors at the right and end with the darkest on the left. I know exactly where to reach for a color because they've been in the same place for more than thirty years.*

he did the rest. I used it for years, until I could afford a professional one. Wooden paintboxes are the best; avoid those made of metal. They're noisy and dent easily. Get a box large enough to hold everything but the easel. I find a 12″ x 16′ box, with a fitted wooden palette and slots in the lid for three panels, a handy size.

Brushes

Now let's consider what goes into the box. Because you're going to carry this collection of "goodies" over hill and dale, keep it simple. For instance, you don't need a fistful of brushes. I get along with half a dozen: numbers 3, 5, 6, 8 and 10 flat, square-ended bristles, plus a small, round, pointed watercolor brush which is handy for fine lines.

Colors

Amateurs usually load themselves down with far too many tubes of paint. Don't expect to buy ready-to-use nature's colors in tubes. Experiment with color mixing and you'll find you can get along with just a few tubes. I carry nine colors, plus white. Here's my landscape sketching palette: titanium white, cadmium yellow light, yellow ochre, raw sienna, cadmium orange, cadmium red, burnt sienna, burnt umber, cerulean blue, and thalo blue. That's it. You'll notice that there's no green listed. I prefer to mix my greens from various combinations of yellows and blues. Let's look at these colors one by one.

Titanium white: This is the most useful white for our purpose. The tube color usually contains an addition of zinc white, put there to harden the softer titanium. It has good covering power—that is, it's very opaque.

Cadmium yellow light: This bright, opaque yellow is useful for mixing greens and for painting sunlit areas.

Yellow ochre: A natural earth color, dull yellow or tan, it's useful in all landscape work. Mixed with the blues, it also produces greens. It's so versatile that it's been called the king of the palette.

Raw sienna: Another earth color, darker than yellow ochre, it's a favorite color of mine. It's great for mixing with thalo blue to obtain rich greens. It's also good mixed with reds and brown for autumn landscapes.

Cadmium orange: Loosely mixed with cerulean blue and white, it produces a variety of grays. With thalo blue, it makes good, deep greens.

Cadmium red light: My only bright red, I seldom use it except in autumn scenes. It's good for that bright, warm touch in an otherwise cool color scheme.

Burnt sienna: Thought of as brown, it's really a deep orange. It can be mixed with thalo blue for deep greens.

Burnt umber: A dark, rich, warm brown, obtained by heating raw umber. It's a rapid drier; a little added to white speeds up drying of the whole picture.

Cerulean blue: A bright, opaque, sky blue, it's useful in the distant parts of a landscape to obtain recession.

Thalo blue: A fine, dark blue, but handle it with care! It's a strong staining color that can take over the whole picture. It's great for mixing with the yellows to obtain greens (as noted above).

Painting surfaces

Next, we must consider what surface to paint on. Although I've painted some fairly large canvases outdoors, I don't recommend it to the beginner. The student lacks the experience and speed to handle a large canvas. Discouragement usually results when it's tried. Landscape painters have used small panels for a long time. A 12" x 16" panel that fits into the lid of the paintbox is a popular size, and a good one. There are several different kinds of panels that you can buy. Some are cardboard with white fabric glued to the surface; others are cardboard or even Masonite that's been sprayed with acrylic gesso.

I prefer to prepare my own panels. They're superior to the mass produced art supply store product—and they cost a lot less. I make a dozen at a time and I make four different kinds. Acrylic gesso, bought in the art supply store, is used for the ground on all four.

I cut some of my panels from ⅛" untempered Masonite, purchased at the local lumber yard. Masonite comes in 4' x 8' sheets. I mark each sheet with a pencil and cut it with a hand saw. Women may find this difficult. For a small charge, the lumberman might oblige if you don't want a lot of different sizes cut out of the sheet.

I first rub the smooth side of the Masonite (don't use the rough side) lightly with fine sandpaper to dull the surface. Then, I give it a coat of acrylic gesso. This first coat is fairly thin, scrubbed on with an old housepainter's brush. When this is dry, I turn the panel over and give the back a coat. This protects the back from future dampness and prevents warping. The front is then given a second and final coat. I use a 2" housepainter's brush for this, first brushing vertically, then horizontally. This second coat should be fairly thick. If you want a smooth surface, you can pat the wet gesso with a wad of cotton wrapped in a rag covering, or you can apply the gesso with a roller. Masonite is a strong, durable material that makes a fine panel.

Another builder's product, lighter in weight and therefore easier to cut, is Upson board. It's much like a very heavy cardboard. This also comes in 4' x 8' sheets and can be cut with a sharp mat knife. It takes two or three cuts to get through it, depending on the strength of your wrist, but it's not impossible. Of course, Upson board isn't as strong as Masonite, but if it's primed on both sides and around the edges to seal it completely, I'm sure it will stand up for a long time. One side has a canvas texture, pressed or rolled into it, which is nice to paint on. A sheet of this material makes a lot of 12" x 16" panels. After all, didn't Lautrec paint on cardboard?

For those who insist on a *real* canvas texture, raw Belgian linen can be mounted on either Masonite or Upson board. Simply coat the panel with a water soluble glue (Elmer's glue); press the linen on; fold it over the edges, allowing an extra inch all around; and glue to the back. When dry, prime this canvas with two or three coats of acrylic gesso. This makes a fine panel for painters who dislike a smooth surface.

A good quality, heavy watercolor paper—the 300 lb. weight—can be used for sketching in oils. As it's rather absorbent, I prime it with a light coat of acrylic gesso. "Panels" of heavy paper take up little room when I'm on a trip. I fasten the paper to a panel of Masonite, securing the sheet with a piece of masking tape at each corner. If a painting done on paper is eventually framed, I suggest that you glue it to a rigid support (like Masonite again) before fixing it in the frame. So much for panels.

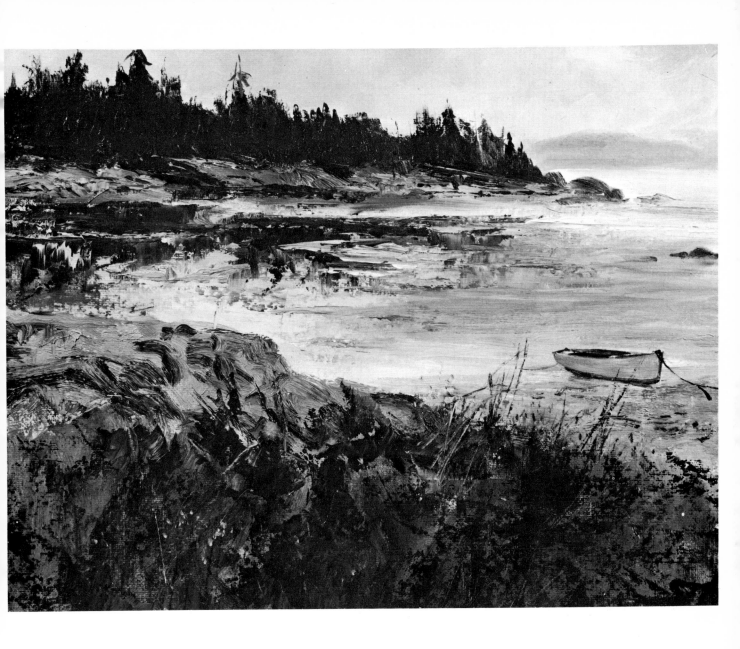

THE POINTED FIRS, oil on canvas panel, 12″ x 16″.

There's a lot of this kind of scenery as you drive down the Schoodic Peninsula in Maine. It's country that very easily brings to mind that great American classic The Country of the Pointed Firs by Sarah Orne Jewett. There's more honest to goodness "Down East" flavor in that book than any I've read. Maine is great painting country—especially in the fall when I usually go there. It's then that the marsh grass we call salt hay turns a beautiful warm gold, and the intense reds and yellows of the maples contrast with the dark greens of firs and pines. All of this color, along with sea fog "burning off" about mid-morning in early October, is more than a humble landscape painter should be expected to cope with. But we try, and keep going back for more. This picture was painted just a few yards off the highway—you don't have to search for subject matter in Maine. It's thickly painted with brush and palette knife; most beginners and amateurs don't use enough paint. There's a suggestion of fog in the distance. The boat wasn't actually there but I needed something in that spot to keep the eye within the composition; in other words it strengthens what otherwise might have been a weak spot in the picture's design.

Painting mediums

Now something is needed to thin the paint as you work. There are many mediums on the market, while formulas for mixing your own can be found in books on artists' materials and techniques. Most of these mediums are rich, oily mixtures, suitable for glazing and studio work. The outdoor painter merely needs something to make the paint workable and to help speed the drying of the slow drying colors.

An old standby is half linseed oil and half turpentine. The oil should be the best quality artist's grade and only gum turpentine should be used. They're mixed simply by shaking them together in a bottle or flask. The heavy, sun-thickened linseed oil can also be combined with turpentine. I've found that a mixture of two-thirds sun-thickened oil to one-third turpentine makes a nice, rich medium, and the faster drying properties of the sun-thickened oil are an advantage.

Another good medium I've often used is Grumbacher's Copal Painting Medium. It dries well, adds some gloss to the paint, and smells good.

The most convenient medium for outdoor work is Weber's Res-n-gel. It comes in a tube and you simply squeeze it onto your palette. I like it because there's no screw-top bottle to bother with. After setting the palette, I mix a little gel with each mound of paint. It's supposed to dry to the touch in twelve hours. (With some of the slow drying colors, such as the cadmiums, this might not be quite true.) It's now the only medium I use when I'm working in the field.

Accessories

What else? Well, you'll need a palette knife. I carry two: one for mixing and scraping, the other to paint with (see Figure 3). You'll have to wipe the paint from your brush from time to time, so have paint rags or paper towels along too. There's always a 6' length of venetian blind cord in my paintbox. I was once asked if it was to hang myself with when the painting went sour—actually, it's used only in windy weather. I tie one end to a rock, the other end to the top of my easel, letting the rock swing a few inches above ground. This holds the easel firm even in a stiff breeze.

The paintbox is now full. You have all that's necessary. However, before you take off, read the rest of the book.

Figure 3 *The palette knife is a useful tool which can be used to obtain all kinds of interesting effects. With it you can work a dark tone over light or vice versa. Care should be taken not to overdo it. Don't let it become a mannerism.*

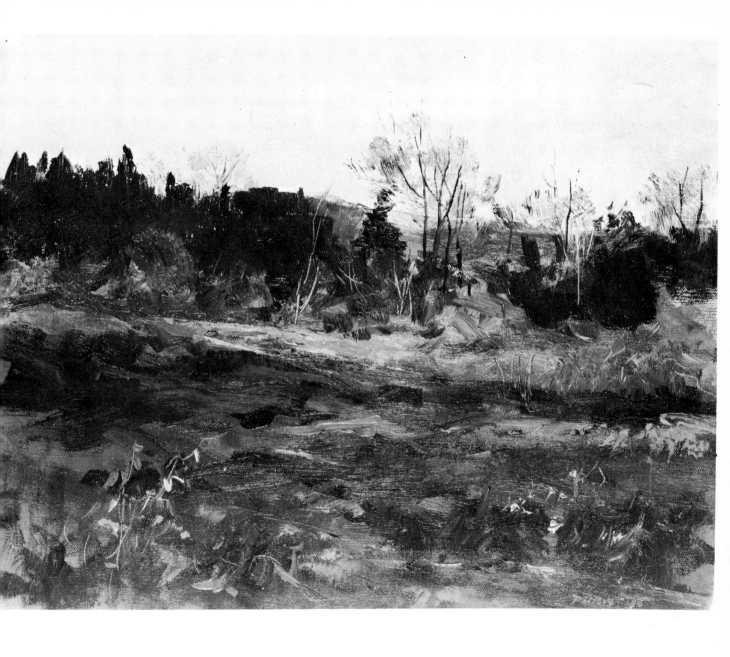

CONNECTICUT AUTUMN, oil on canvas, 16" x 20".

I wish all the pictures could be reproduced in color. This one has a rich variety of deep color enhanced by the light tones of the sky. The time was mid-afternoon in November. The leaves were gone from the trees, allowing the dark conifers to stand without competition. The foreground was simply treated in order that the eye might move easily to the band of trees in the middle distance. This was my point of interest, where I concentrated my suggestion of detail. Notice how the twig masses on the bare trees have been handled. Amateurs and beginners often paint winter trees with branches only. They forget that thousands of overlapping twigs form a mass which at a distance becomes a gray tone. They make this mistake because they haven't learned to observe. And good painting is based on good observation. November is a good tree-painting time here in the East. The overpowering color of October has gone and the monotony of summer green is just a memory. Yes, early November is a great time to be alive—and to be landscape painter.

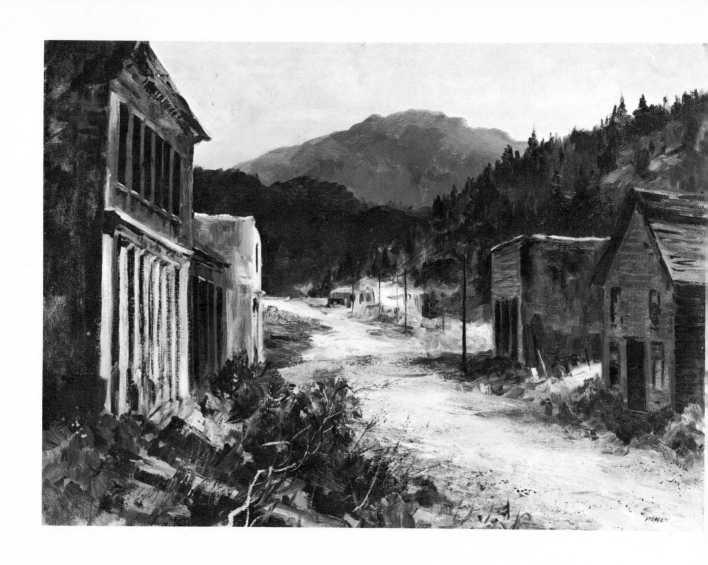

NEVADAVILLE, oil on canvas, 20″ x 28″.

Nevadaville is a ghost town in Colorado. It was part of the 1859 "Pikes Peak or Bust" gold rush. My picture shows how its main street looked when I was there with a Painting Holidays group in 1968. It's hard to believe that this derelict of a street once boasted thirteen saloons and other places of nocturnal amusement. The town was settled by my countrymen from Cornwall, England. In the mining camps these men were known as "Cousin Jacks." Fights on Saturday nights were commonplace and there were many murders. I'm sorry this isn't reproduced in color because the warm tones of foreground, road, and buildings *create a nice contrast with the cold blue of the distant mountain. This is a studio painting made from a watercolor (half-sheet) painted on the spot. I used sun-thickened linseed oil as a medium. My usual practice is to mix a couple of drops with each mound of paint on the palette, stirring it in with the palette knife. Pictures painted with sun-thickened oil dry with a gloss and never seem to need varnishing. If you're the mat finish type, leave it alone, but I like my oils to have a little shine. I hope to return to Nevadaville someday just to stand on Main St. once again and be the only "Cousin Jack" in town.*

Fundamentals of craftsmanship

TODAY, THE tube colors bearing the names of well-known manufacturers, both foreign and domestic, are the best and most reliable ever offered. There are many colors to choose from—too many.

Limited palette

Some painters just can't resist the tempting lists of colors in the manufacturer's catalog, often buying more than they really need. What's worse, they become accustomed to a palette set with such an array of colors that it resembles a patchwork quilt. I've actually read of a palette of twenty-five colors recommended for landscape work. This is more than twice the number found in my paintbox!

I think that choosing colors is an individual matter, but I do suggest that the beginner start with no more than the ten colors I've listed in Chapter Two. Those ten have served me well for each season of the year. Of course, this palette has its limitations, for instance, the elimination of a red like alizarin crimson. It's a lovely color, good for certain flowers and flesh tones; but for landscape, forget it.

No black, no green

Sometimes I've been asked how I get a good dark without using a tube of black. Believe me, black is the *last* color I'd think of using for a dark. I was taught very early in the game that black is the absence of light, and if there's any one thing a landscape should have, it's an illusion of light. A deep, rich dark can be obtained with a mixture of burnt umber and thalo blue. So why black?

Other darks can be mixed with various combinations of the colors on my palette. However, as I have but two—burnt umber and thalo blue—that can be described as *dark* colors, the mixtures must be based on one or the other or both. Mixtures of some of the other colors on my palette, such as burnt sienna with raw sienna or yellow ochre, will produce a dark tone but I wouldn't call it a deep dark.

Then, the fact that there's no green on my palette raises an eyebrow or two. But why buy prepared greens when I have the colors to mix any green I want? My summer landscapes, laden with foliage, have never suffered from the lack of a tube of green in the paintbox.

Rich dark greens can be obtained with thalo blue and raw sienna. The greens can be made cool or warm depending on the proportion of one to the other. The

more blue you add, the cooler and darker the mixture becomes. Raw sienna will not make a brilliant green, but with a little thalo blue those heavy, lush, summer greens are yours for the mixing. For bright sunny greens I mix cadmium yellow with a little thalo blue.

Burnt umber and thalo blue mixed make a tone that's almost black but, in my opinion, better because it seems to have more life—or perhaps I should say luminosity.

Burnt sienna with thalo blue creates a dark that's difficult to describe. I've heard some painters call it green; some say it's brown. I sometimes use it in foliage, so I say green.

If you add alizarin crimson to the palette, you have the makings for one of the greatest darks. Mix it with thalo blue and you have a dark as deep as black but twice as handsome—it's really a deep purple.

Complementary colors

The beginner should experiment with color mixing. Book learning is all very well; but in the end, you have to take up your brush or knife and mix in order to *see* what happens, for instance, when you mix any two complementary colors together. Having worked with students for a long time, I never take anything for granted. So for those who may not know what the complementaries are, I'll explain.

Let's start first with the primary colors: red, blue, and yellow. These are the important trio. By mixing any two of these primary colors, you produce the complementary to the third primary. For instance, you mix blue and yellow to get green—the complement of red. Mix red and yellow and you get orange, which is complementary to blue. Now, if you mix red and blue, you get purple, and that complements yellow. So you see, it's no mystery—very simple really.

Purple, orange, and green are called secondary colors. Combine any two of them and you get what's called a tertiary color. But unless you're going to be a paint chemist, let's stop there.

Warm and cool colors

Painters call some colors warm and others cool—and it's true that warm colors appear to advance and cool colors seem to recede. Orange, red, yellow, yellow-green, and brown are what we call warm colors. We think of blue, violet, and blue-green as cool colors.

To obtain the illusion of depth, the landscape painter will often use cool color for the distant parts of his picture and place a warm note in the foreground.

Graying down a color

To gray a color, you simply add a little of its complementary color. A touch of red will gray or tone down a green; some orange will reduce the intensity of a blue. It's not true that you have to go all out for contrasts of intense color to paint a brilliant, sunlit landscape. There's a lot of gray in nature.

I recall a picture by Sargent in New York's Metropolitan Museum of Art called *The Hermit*. It's a forest interior, full of flickering sunlight and shadow, yet all painted in subtle grays. Nature uses color subtly. The landscape painter must train his eyes to observe the subtleties of color in nature as well as the more obvious color effects.

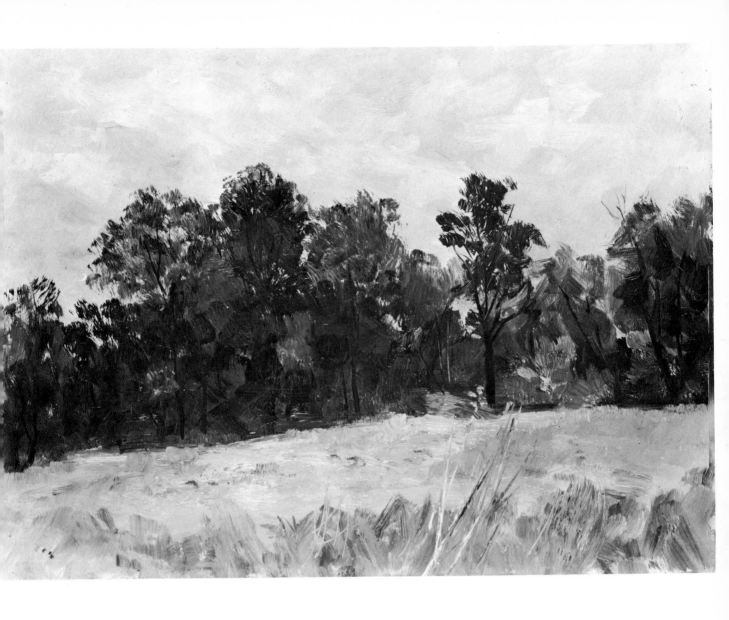

THE MONTH OF MAY, oil on gesso panel, 10" x 14".

How often have we heard, "I'm looking forward to spring." It's probably heard most often in the northern part of the country where the winter is long. Where I live in New England, spring is a beautiful time of year. There are many signs of it in April, but it bursts forth in its full glory in May. The painting shown here was started as a tree study and a color experiment. I wanted to see if I could paint an acceptable spring picture without a tube of green in the paintbox. I think I succeeded fairly well. My greens were mixtures of cadmium yellow light, yellow ochre, raw sienna, cerulean blue, thalo blue, and white. I've kept this study in order to demonstrate to students the importance of learning what your colors can do. Although color is a very personal thing and great colorists are rare, much can be learned by experimenting with color mixtures. Green though the most dominant isn't the only color of spring. Early in the season look for the subtle violets of the bare twigs. A little later there are the reds of tree buds ready to open. Then come the warm and cool grays; there are beautiful grays everywhere. There are always grays in nature throughout the seasons.

Studying nature

If you're a real nut about landscape painting, then you're also a nature lover. You can't be one and not the other. There's a vast difference between the works of the artist who constantly studies nature—memorizing her changing moods and *going to her* with paints and brushes—and those of the man who manufactures studio concoctions from his memories of other artists' works.

The paintings of the artist who works from nature have the feel of weather in them, the authentic look of nature. They have air you can breathe. They invite you in. If you're a good observer, and also a lover of nature, you know that the artist was *there*—on that particular spot—when he gathered his material or painted his picture. Not so with the picture manufacturer. He may be a sensitive painter and a very fine craftsman. He may even have popular success. But that certain something—the authenticity that the "go-to-nature" painter gets into a landscape—isn't present in the artificial studio concoction, no matter how beautifully it's painted.

You may say that this isn't important: "A good picture is a good picture." True, so it is, but in this book I deal only with landscape painted from nature, and I present the thoughts of a painter who has always enjoyed this special challenge.

Setting the palette

How should a palette be set? The important thing is that it should always be set the same way. You should know the location of each color without having to think about it or search for it.

Some painters place their white paint in a central position, with the warm colors on the right and the cool colors on the left. I place my white at the far right and follow it with my lightest colors, ending with my darkest colors at the far left. From right to left, the palette is set in this manner: white, cadmium yellow light, yellow ochre, raw sienna, cadmium orange, cadmium red light, burnt sienna, burnt umber, cerulean blue, and thalo blue. I've always set my palette that way. No one taught me to do it. It just seemed logical. If I changed the order now, I'd be lost.

Painting mediums and dryers

Having set out the colors on the palette, I next add a little gel medium to each mound of paint and mix it in with the palette knife. This distributes the painting medium evenly throughout the paint, making it nicely workable for use with brush or knife. I seldom have to use any additional medium when I'm working on an outdoor sketch. Gel imparts a buttery quality to the pigment, which is desirable for rapid outdoor work.

When I use a liquid, such as copal painting medium, the same procedure is followed. I dip the blade of the palette knife into the bottle, allow a couple of drops to fall from the blade onto the paint, then mix it in.

To use or not to use dryers has been debated for a long time. A little added to the slow drying pigments can do no real harm—but it must be a *little*. It's powerful stuff. The only dryer fit for artists' use is cobalt linoleate.

Of course, the student should learn what paints are the slow dryers, rapid dryers, and average dryers. The drying rates of the paints on my landscape palette are as follows:

Slow dryers: white, cadmium yellow light, cadmium red light, cadmium orange, yellow ochre, cerulean blue.

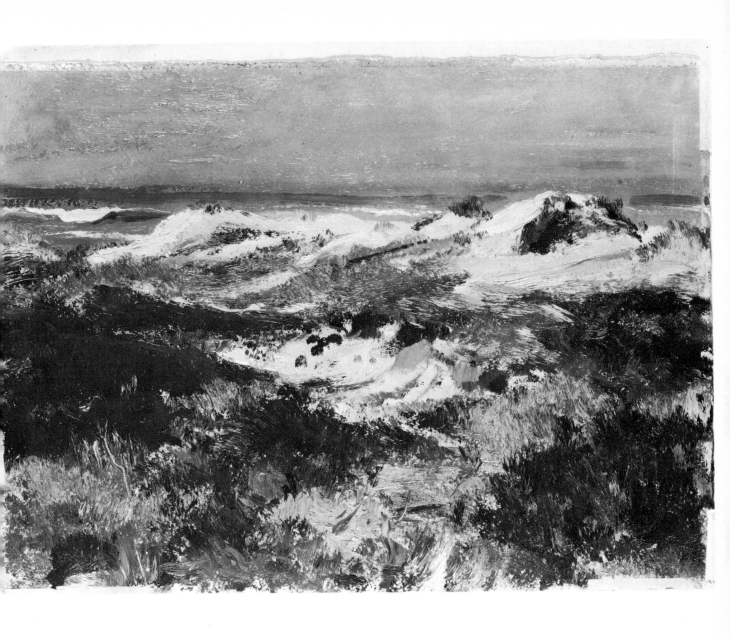

BEHIND THE DUNES, oil on watercolor paper,
12″ x 16″.

*Painting with oils on watercolor paper isn't a new
idea. John Constable used it and so have many
other landscape painters. For working outdoors,
the paper can be taped or glued to a Masonite panel.
I find that cold pressed paper has a nice surface to
work on. However, it's rather absorbent unless
primed. I usually give the paper a thin coat of one
of the water based house paints. Then when dry,
I tone the surface with oil paint thinned with tur-
pentine and a little damar varnish. For some panels
I use a cool gray tone, on others a warm tone made
with a mixture of burnt sienna with some white.*

*This picture was painted on Jones Beach, Long Is-
land, New York. The dunes in the autumn are
lovely in color. The beach plum bushes and bayber-
ries become quite purple, and mingled with the
ochres and warm greens of the coarse grass, the
color is quite beautiful. The light value of the sand
creates good contrast. To place emphasis on this
contrast, I made the sky darker than it really was.
Once again, never hesitate in taking liberties with
nature if they can improve your picture. Before
you do, though, be sure you're right.*

31

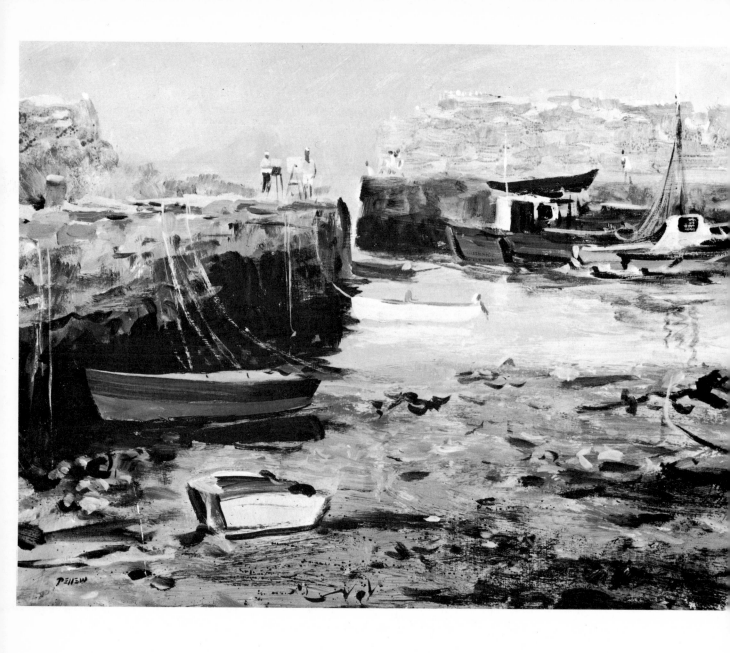

LANESVILLE, oil on gesso panel, 12″ x 16″.

I've lost count of the number of sketches I've painted in this favorite artists' haunt. All summer long you can see them at work here. In this picture, at the end of the wharf there's a couple painting. Because quarries were once the great industry on Cape Ann, Massachusetts, the piers enclosing the little harbor at Lanesville are made of huge granite blocks. This gives the place a very European appearance, reminding one of the shores of Brittany and Cornwall. This was painted on a bright, sunny September morning. It's in a high key and quite colorful. The grays of the stone piers
serve as a foil for the bright color of the sky, water, and boats. Notice how simply the group of boats at the upper right have been suggested. This is a kind of outdoor sketcher's shorthand. The beginner would paint these distant boats too carefully, so carefully that the mood of the sparkling sunny day would be lost. The two painters, though small, are placed where they become the point of interest. When they left I noticed their car carried a California license. Lanesville certainly attracts painters from far and near.

Rapid dryers: burnt sienna, burnt umber.

Average dryers: raw sienna, thalo blue.

Used with the gel or copal mediums I recommended, the pigments listed above should dry within a reasonable time *without* the addition of dryers. However, if it's desirable to speed up the drying for any reason, a little dryer can be added to the slow drying colors. Add one drop of dryer to a mound of paint the size of a pecan nut, and that should be enough. Over-use of dryers will cause cracking and darkening of the paint, so beware.

Keeping leftover paint

How can unused paint be kept for use the next day? This is a question often asked. The best answer is—don't have any left over. The sketch will probably look better for a rich, thick application.

Actually, paint dries slowly in the dark, so keep the paintbox closed with the palette inside. The paint should be in good condition next morning. If there's quite a lot of paint left over—say, when you're working on a large canvas in the studio—it can be kept under water overnight. For this, you'll need a shallow tray that holds about an inch of water. The paint is placed on a sheet of glass and submerged in the water. This keeps the air away from the paint. Without air, the paint won't dry. Next morning, pour the water off and go ahead with your painting.

But, it's better to learn how much paint you need for the size of the panel or canvas you're using; it saves a lot of trouble.

Cleaning brushes

A good craftsman takes care of his tools. There's nothing artistic about a sloppy paintbox or brushes stiff with old, dried paint.

At the end of each day's work, your brushes should be cleaned. I first swish them around—one at a time—in a can of kerosene; then I wipe them on a rag to remove most of the paint. Next, I use warm water and Ivory soap, scrubbing the brushes back and forth in the palm of my hand until all the paint has been removed. If good quality brushes are treated in this manner, they should last for years.

By the way, kerosene is better than turpentine for brush cleaning. Turpentine hardens the bristles. Besides, kerosene is a lot cheaper.

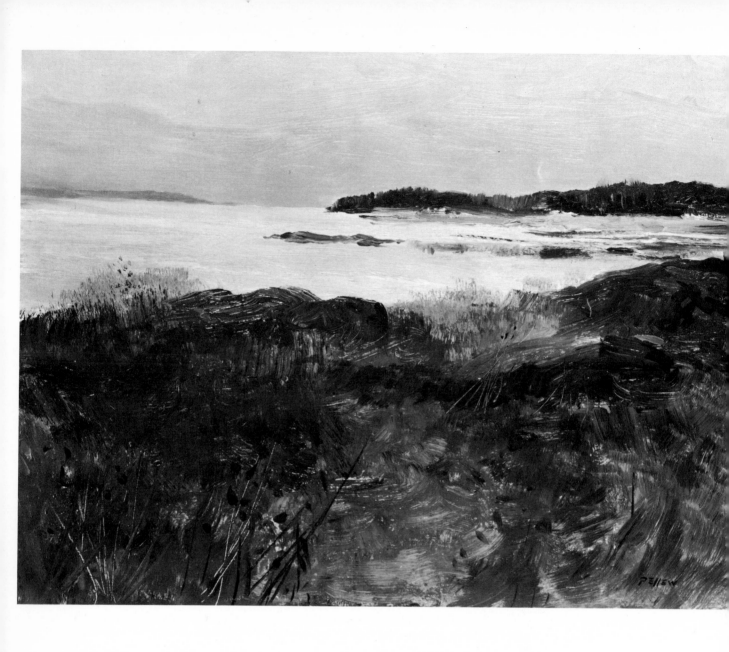

THE MAINE COAST, oil on gesso panel, 9″ x 12″, collection of Mr. and Mrs. Kenneth W. Paul.

A quiet autumn day on Penobscot Bay—it's a nice time of year to be there. Although there was a fog bank offshore, the water was being lighted from above. The weedy foreground was mostly in shadow. Study my division of the picture space. Notice that each of the three main shapes—foreground, water, and sky—are different in size. The relative size of the big shapes in a landscape should be given careful thought when planning the composition. In order to retain the mood of the day, I kept my brushwork quiet, avoiding any attempt at spontaneity. There was no palette knife work here. The only thing not done with the brush were the scratches suggesting weed stems in the left foreground. For these I used my fingernail.

Face to face with nature

WHAT'S THE most common mistake made by beginners when they first paint from nature? Easily answered: they try to say too much.

Don't say two things at once

The American painter Birge Harrison gave some good advice on how to overcome this tendency in his book, *Landscape Painting*. He said that the first rule in landscape composition is: don't try to say two things on one canvas. Any motif that's worth painting must have a central point of interest. Concentrate on that. If there happens to be another attractive feature in the same subject, ruthlessly suppress it so that the *one* thing you have to say may be said strongly. This is the meat of his advice, and good advice it is.

Use a viewfinder

Nature, of course, is bewildering to the student painter. It was to me. Experience will solve the problem of selection in time.

However, there's a little gadget that can be helpful. It's called a viewfinder and it's simply a piece of cardboard, about the size of a postcard, with a rectangle cut out of its center. When you're searching for a subject, hold the viewfinder up to nature, keeping the card about 15″ from your eyes. Move it around; look only at what you see framed in the little window in the center of the card.

This device will force you to concentrate on one area and will keep you from attempting to paint miles and miles of countryside. It's easy to make. Always have one in the paintbox.

Paint what you see

Another common error made by beginners is trying to paint too much unimportant detail.

For instance, instead of thinking of a tree as shape, color, and value—which is the right way—they become concerned with individual leaves. They don't really see the leaves on a distant tree, but they *know* that the leaves are there—so they try to paint them. Most students have to be taught to *observe* because they have a tendency to put down what they know about an object instead of what they actually *see*. Remember that when you paint from nature, you're practicing a visual art.

Figure 4 *Make yourself a viewfinder by cutting an opening in a piece of heavy cardboard. The opening should have the same proportions as the canvas or panel you intend to use. Make it a convenient size; a little larger than a postcard will do.*

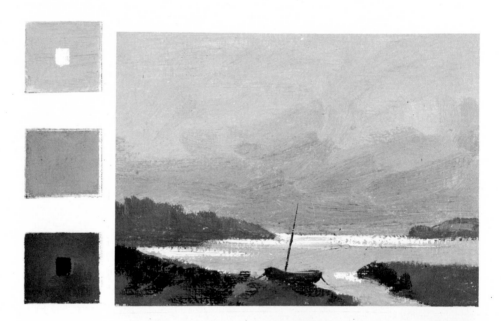

Figure 5 *Two subjects are painted in three values in this demonstration. Try some black and white sketches of this kind. On your palette mix the three values shown in the major portions of the little squares (above). Paint a landscape using only these three values. Hold back the lightest light and the darkest dark (the two small interior squares) until last. Now use them with discretion where you want the eye of the viewer to linger. This kind of practice will teach you not to break up your value pattern with too many spotty lights and darks.*

It may seem like an exaggeration to say that most people really don't see the world around them, but it isn't. The best proof of this is the person who takes up art as a hobby upon retirement. I've heard many of them say, "I'm seeing things I never saw before." Why is this? The answer, of course, is that they're learning to observe with a purpose. The average person looks at the world while thinking about something else. He may be looking at cherry blossoms reflected in a pond and part of his brain tells him it's pretty, but at the same time he's thinking about some troublesome business at the office, or what he'll get his wife for her birthday. So the cherry blossoms become a pleasant, but rather hazy, memory.

What's so different about the professional landscape painter's observation? He looks at the cherry tree and its reflection, and his first thought is that it's beautiful (not pretty). Then, he observes how the branches disappear into the blossoms and wonders how the effect could be shown in a painting. Next, he might ask himself if the blossom on the sunlit side of the tree is really lighter in tonal value than the sky. Is the reflection of the blossom darker than the blossom itself? You see, he observes the world as subject matter to be painted. A tree is not merely a tree—it's a shape with color and tonal values. Oh, he'll enjoy its beauty, but he'll be doing his homework at the same time.

Some beginners neglect this kind of study when they start painting. At first you need some concentration, but it soon becomes a habit. The average person need not be concerned about the landscape he views—except to enjoy it. However, the art student with an urge to paint landscapes must observe and learn to think like a professional painter in terms of color mixing, composition, values, etc.

I can't tell a student how to observe, except in the terms indicated above. I've been asked, "How do I know what to leave out?" Well, leave out all the detail, and put in the big shapes and masses. Keep it simple. Learning to observe is just a matter of *thinking* while you *look*.

Learn to see values

All painting that attempts to depict reality is simply an illusion created by the painter. This illusion is obtained chiefly by the correct relationships of the tonal values, not by minute detail, as many seem to think. A very simple statement will have reality if the tonal values are correctly related.

The beginner often seems to have a rough time learning to understand values and their importance in realistic painting. Value simply means the lightness or darkness of an area, shape, or object. Just as the beginner will try to paint individual leaves he can't see, he'll also paint dark what he sees light, and vice versa.

Once, when I was conducting an outdoor class, I asked a young lady if the treetrunk she was painting was lighter or darker in value than the foliage behind it. She said, "I never thought of it that way; aren't treetrunks just brown?"

Observe nature constantly for the difference in value between one object and another. Compare one value to another as you work. Ask yourself: "Is it lighter or darker than what's beside it? If lighter, how much lighter? If darker, how much darker?" Don't be afraid to talk to yourself—we all do it. You'll soon learn to see the tonal value pattern in a landscape if you observe carefully, and *think* (see Figure 5). Correct value relationships create the illusion of reality.

Notes on composition

Some books on art give the subject of composition a lot more space than they give to the study of tonal values. I don't go along with that. If a person has good

taste in most things, he'll probably compose his pictures tastefully. What's composition but the arrangement of shapes within a given space? I've seen beginners make excellent landscape compositions, but I haven't seen one yet who had a really good understanding of tonal values. Of course, there are some who never make a good composition, even after they've become pretty good painters. But that only proves my point.

There *are* some tried-and-true rules of composition that may as well be learned. Don't divide the picture space through its center—that's a good rule. In a landscape, have more sky than land or more land than sky—that's another (Figure 6).

When you're painting anything reflected in still water, don't make the reflection as important as what's being reflected. Feature one or the other. Wouldn't you think anyone would know that? They don't seem to. Year after year, I see pictures of trees reflected in a pond—pictures that could be turned upside down, and not a soul would know the difference.

The landscape painter must *arrange* the material that nature presents to him. Whistler put it this way in his "Ten O'clock" lecture: "Nature contains the elements in color and form, of all pictures, just as the keyboard contains the notes of all music. But the artist is born to pick and choose, and group with science, these elements that the result may be beautiful—as the musician gathers his notes, and forms his chords, until he brings forth from chaos glorious harmony. To say to the painter that nature is to be taken as she is, is to say to the player, that he may sit on the piano."

The golden cut

It's a long time since I've heard an artist mention the "golden cut" when talking about composition. Fifty years ago, many painters knew about this, as did the ancient Greeks. Applied to a horizontal line, the golden cut is the division of the space. (See the diagrams in Figure 7). It's a spatial division that's always the most satisfactory in landscape.

Look at the first diagram and think of that line as the horizon, with the sky above and the land below. Of course, it's just as good turned upside down. Remember what I've said about more land than sky or more sky than land?

In the second diagram of Figure 7 consider that vertical line a tall, dominant tree, or, perhaps, a boat's mast. Where else would you place it? By keeping this in mind, you'll always avoid dividing the space through its center.

If a student wants to learn something about composition, then he must also study the subject of proportion. There's no better way of doing this than to learn about the golden cut. The proportions of it occur over and over in nature: the placement of the eyes in the head, between the top of the forehead and the bottom of the chin, is one example. Then, there's the position of the mouth, between the base of the nose and the bottom of the chin.

Look around and see this cut, or proportioning, for yourself in nature (see Figure 8) and in great works of art. A careful study of Whistler's works will convince you he was aware of it. The American nineteenth-century luminist painters, Fitz Hugh Lane (1804–65), who's said to be Wyeth's favorite painter; John Frederick Kensett (1816–72); and Martin Johnson Heade (1819–1904) certainly made use of the cut in their landscapes. It may not have been a conscious effort on their part, but it was there. Of course, it could be they were just good designers by nature.

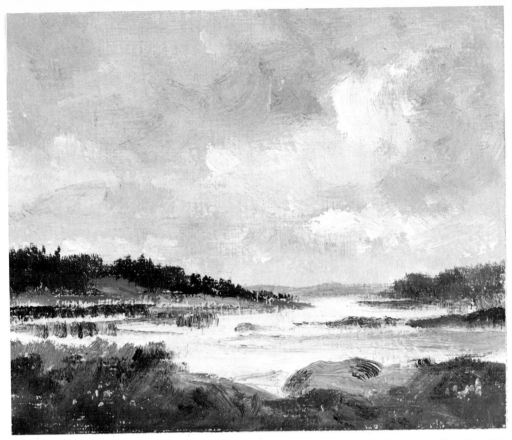

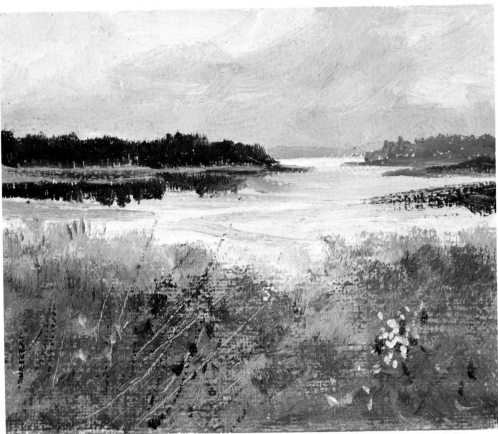

Figure 6 *With these two sketches I'm demonstrating that the same subject can be painted with either a low or a high horizon. It's best to keep the horizon well below or well above the center of the canvas—more sky than land or more land than sky.*

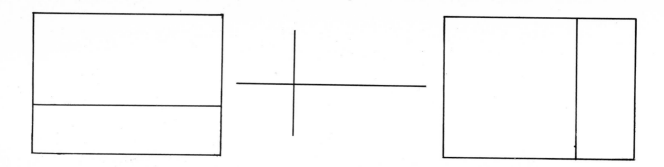

Figure 7 *The old timers called this the "Golden Cut." If a horizontal or vertical line is drawn dividing the canvas into these proportions, for some reason—don't ask me why—the rest is pleasing.*

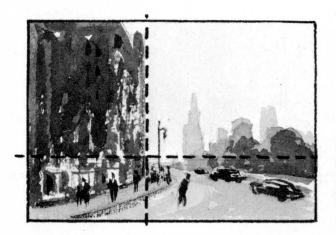

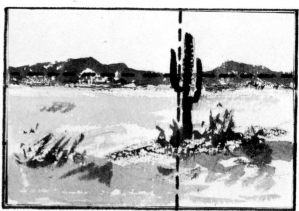

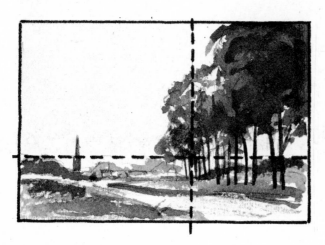

Figure 8 *These three sketches demonstrate the the "Golden Cut" applied to a landscape. The dotted line indicates that the division of the picture space is the same in all three. You don't have to use this spatial division for every landscape you compose, but this cut or division seems to be the normal or satisfactory one. Notice that the horizon in the drawing directly above is the same distance from the top of that sketch as the horizons in the drawings at the left are from the bottom of their respective sketches.*

The abstract pattern

I've said good composition is a matter of good taste, and I believe that to be true although it may be an oversimplification. So give the golden cut some thought, and while you're about it don't forget to think about the abstract pattern of your landscapes. It's difficult to explain an abstract pattern in words. Try to imagine all the detail disappearing from a landscape painting. All that's left is a pattern of shapes—some light, some dark, and some in-between tones. If the painting is well designed or composed, these remaining shapes will form a pattern that in itself is a good design. A poor composition will never break down into a good abstract pattern, because without the details, and possibly the tricky brush-work, it won't hold up as design.

In my black and white sketch (see Figure 9), I show how to "abstract" a painting. Try doing it to some of your pictures to see if they are based on a good abstract pattern.

Keep it simple

When I watch a student painting from nature, the advice I give most often is "keep it simple." Simplification is a difficult thing to learn—but how important it is!

The tendency is to add more and more detail. This is because the beginner looks at only one part of the picture at a time. The painting takes on a patchwork appearance instead of having the "oneness" that all good landscapes should have.

When you're viewing nature, it's natural to look at the middle distance. This is the part of the landscape you normally see most clearly. You can see sharp detail in the foreground only if you shift your point of view and look down. But remember, you can't look up and down at the same time; you can't see foreground and middle distance with equal precision. So paint the foreground as you see it when you're looking at the middle distance; in other words, paint the foreground boldly and simply (Figure 10).

Simplification is a matter of painting the *mass*, and merely suggesting the detail. When you attempt to paint individual blades of grass, or every leaf on a bush, you're carrying a still life approach to nature—and that isn't the business of the impressionist.

Paint an impression

It's on record that Matisse once asked Pissarro, "What is an Impressionist?" Pissarro replied, "An Impressionist is a painter who never paints the same picture, who always paints a new picture." I take this to mean that the impressionist paints his impression of a landscape at a definite time of day or under a particular effect of weather. The same scene, painted six hours later, or on another day, would be a new picture.

An impression is what the student of outdoor painting should strive for. When I'm painting from nature, I try for the mood rather than for the detail. This calls for rapid execution in order to capture the desired effect. You must work with all the speed at your command. Sunlight and shadow don't stand still. What looked enchanting when you started to paint may be commonplace an hour later.

You don't have to imitate the painters of the great French impressionist school unless you're very sure that's really for you. A sketch by Constable doesn't look like a Monet, yet it's an impression.

Figure 9 *I'm fond of saying that every picture, even the most realistic, must be based on a good abstract pattern. However, I find that difficult to explain in words. What makes an abstract pattern good or bad? I guess it's a matter of design, balance, and perhaps unity. The abstract pattern seen above was taken from the landscape sketch beneath it.*

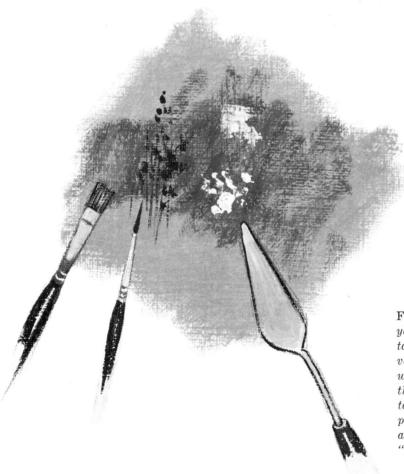

Figure 10 *When viewing a landscape, you see the most detail in the middle distance. My sketch shows a foreground very simply treated. The detail of grass, weeds, etc. runs through the center of the space. You only see foreground detail when you look down at it. When painting a landscape, you can't look up and down at the same time. Corot said, "My foreground is sixty feet ahead."*

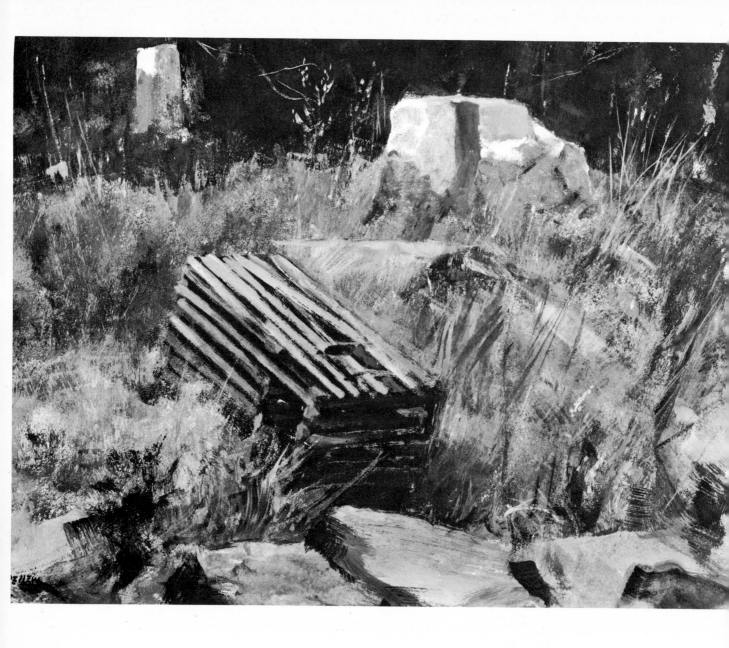

THE DERELICT, oil on gesso panel, 12″ x 16″.

I guess you'd call this a closeup, a type of composition that has become quite popular in recent years. Andrew Wyeth did much to make it popular although he was by no means the originator. In fact, Albrecht Dürer did some very nice closeup studies of wild flowers, weeds, etc. Then, there are the lily ponds of Claude Monet which, of course, can be described as closeups. What makes this type of picture different from a still life setup? The main difference is that it's an outdoor painting in which the artist is concerned with the effect of natural light on objects that are painted as found—not arranged. The point from which the objects are viewed is of the utmost importance because the closeup must be carefully composed. The abstract pattern within the four borders must work. In my picture notice how the eye goes first to the lobster trap then up to the light-toned rock, top right. It's then caught by the smaller upright stone post at the left and so has moved easily through the composition. Did I think all this out before I started? No, not really—but the student should. I organized the composition intuitively, not because I'm a "big brain," but because, after having made hundreds of compositions, I'm experienced.

Notes on painting specific subjects

WHEN THE beginner first goes to nature, paintbox in hand, to have a go at landscape painting, he often searches for a subject that reminds him of a favorite painter. This is a mistake. Don't have preconceived notions of what the "right" picture material consists of; don't let your admiration for another's work unduly influence your choice of subject matter.

Selecting your subject

Park the box and easel against a rock or tree and walk around for a while. When something hits you hard enough to make you say "that's good," you've found your subject. It must be interesting for itself alone, not for some favorite painting that it reminds you of.

There are some students who walk and walk and never seem to find anything to paint. With them, I think it's a state of mind. They'll see a motif, but they'll tell themselves that there will probably be a better one around the bend. And so they'll wander on in a state of indecision, ending up mentally exhausted, throwing pebbles into the brook.

My advice to this student is: paint the *first thing you see* that looks promising. Give it all you've got. Your interest will awaken as you get on with the job and your painting begins to develop.

The best time of day

When I'm asked what's the best time of day to go painting, I give some good advice which, unfortunately, is seldom taken.

In summer, the best time is from 7:30 A.M. to 10 A.M. That first figure tells you why my advice is so often ignored. I don't say that a great landscape can't be painted at high noon. However, the beginner had better not tackle it. At midday, the light is directly overhead; there's no definite light and shadow pattern to model the forms of objects as there would be earlier in the day, when the sun is lower in the sky.

Of course, you *can* go out to paint after 3 P.M., but I just can't work up enough steam to do that. The light is good, the color is rich, and the shadows are long. But along about four o'clock, I start thinking about my before-dinner cocktail and what I'm going to do in the evening. Besides, I've probably worked all morning at something and I want to relax. So, I say paint in the morning, as early as you can make it.

Trees

No two trees are alike, yet the beginner often paints them all alike—usually like a green sponge on a stick. The student should fill a few sketchbooks with drawings of trees. Carefully study the characteristics of the different types (Figure 11). Trees, like the waves of the ocean, have an anatomy that must be learned, if the artist is to do anything convincing with them.

When sketching trees, consider the big, overall shape before you start looking for details (Figure 12). This is as true of bare trees as it is of those in full foliage. For instance, the elm's overall shape is quite different from that of the willow or the oak; and neither is at all like the beech or maple. Then there are the conifers, those beautiful evergreens—the pine is different from the cedar or the hemlock, and so on.

It's easy to see that trees are a lot more than a green ball on a stick. Trees are lovely things. They have beauty and character. Sketch them, paint them, and learn to love them as I've done.

Brushstrokes

The brushstroke is the handwriting of the artist and should be just as personal. I think it's wrong to tell a student to use a definite type of brushstroke to obtain a certain effect. I can only demonstrate my way, as I have done in some of the black and white demonstrations.

Sure, I often use the palette knife when painting foliage, but someone else could do it with a brush. Where I use thick paint, they may use a thin paint application. If the results are good, then the technique is unimportant. Great pictures have been painted in which you are unable to detect any brushmarks at all. Others have been so heavily brushmarked that you have to stand off ten feet before the painting pulls together and makes an image.

The brushstroke of John Singer Sargent has a lot in common with the brushstroke of Frans Hals because Sargent believed in spontaneity, but it has nothing whatever in common with the brushwork of Jan Vermeer, who was quite a different type of artist, but also a great one. While you're learning, the best advice I have to offer is let your brushstrokes follow the form of what you're painting (Figure 13).

Grasses and weeds

The landscape painter should become familiar with everything that grows outdoors. Well, maybe not with *everything*, but you should have a nodding acquaintance with what grows in your own particular part of the country. Of course, that will include the grasses and weeds that so often become the material of your foregrounds.

Unless you're painting a closeup study, the weeds, grass, and other growth of a landscape foreground should merely be suggested. Remember, you can't see details in the foreground while you're looking at the middle distance. That is, you can't look down and up at the same time.

The watercolor painter suggests his grassy, weedy foreground by making use of a technical method called *drybrush*. The oil painter uses a similar technique called a *scumble*. This is a dragging stroke with a loaded brush over a somewhat rough, previously painted area. Scumbling can be done with a dark paint over light paint or vice versa (Figure 14).

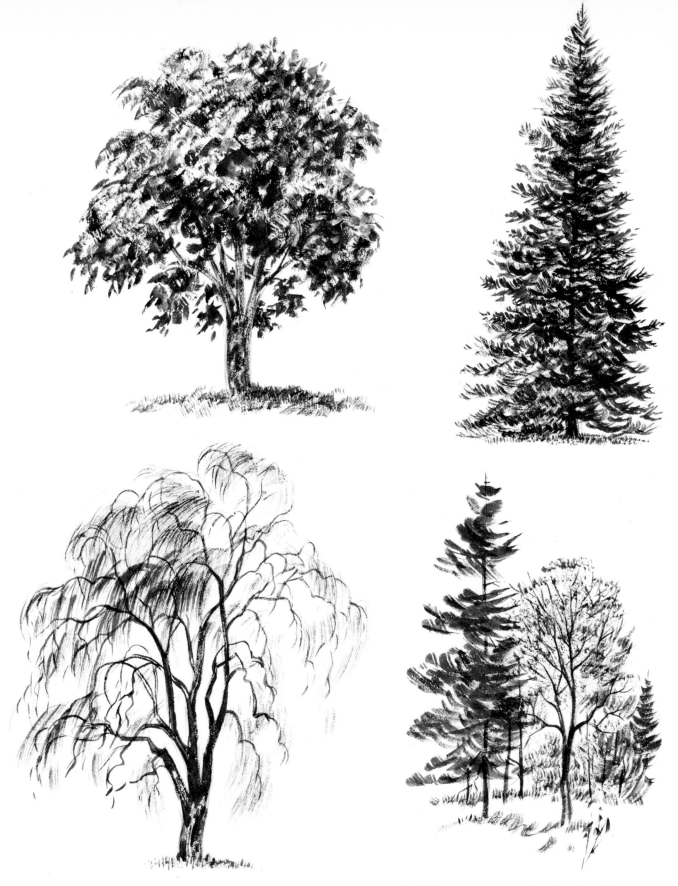

Figure 11 *Learn the characteristics of the different tree types by drawing them from nature. Don't try for artistic results. Let your drawings be anatomical, as realistic as you can make them. When sketching trees, I get the best results using a drybrush technique executed with a well worn watercolor brush and waterproof drawing ink.*

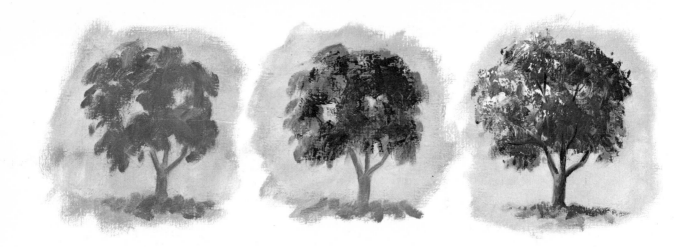

Figure 12 *This is a simple exercise in foliage rendering. After the sky has dried, paint the tree over it. Paint the foliage mass with a green tone that you feel matches the middle value (first step, left). Then, mix a dark green corresponding to the darkest value. Scumble this over your first lay-in using the side of the brush. The effect should be like that shown in my middle step. Now apply your lightest green with the palette knife, dragging it flat over the surface. Keep a definite light direction in mind. My tree is getting light from the upper left (final step, right).*

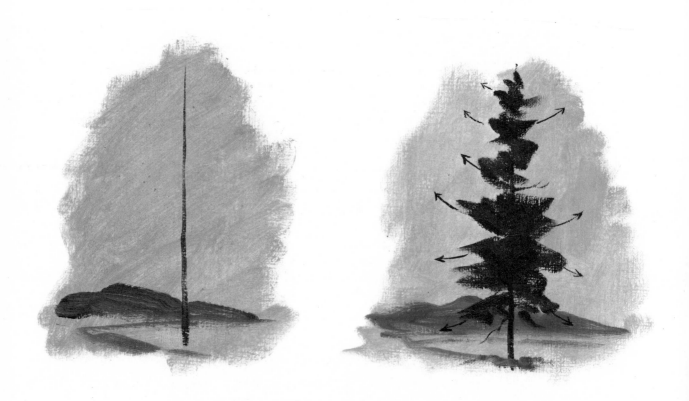

Figure 13 *Here's the swiftly stated impression of an evergreen tree. In the first sketch (left), I start by drawing a vertical line with the brush; this is the trunk. Next (right), with a fully loaded brush—the regulation flat bristle—I start at the top and rapidly move downward with a side-to-side movement, first one side then the other. The arrows indicate the direction of the brushstrokes.*

Some individual weed stems or blades of grass may also be scratched into the wet paint with the point of the palette knife or the brush handle (Figure 15). This is a good trick—one that has been used by some of the masters. However, like all tricks, it becomes a bore when overdone.

Wildflowers in the foreground grass can be suggested—remember, I said *suggested*—with a spatter (Figure 16). This is done by dipping one brush into fairly liquid paint and tapping its handle on the handle of *another* brush, allowing the paint to splash or spatter onto the grassy foreground. This is a lot of fun, so don't get carried away.

Houses and barns

Introducing a house into a landscape always seems to give the beginner a good deal of trouble. After looking at hundreds of student paintings in which a single house was intended as the point of interest, I think I know why. The two most common errors are making the house too large for the picture space and placing the building right in its center. This also happens when the amateur paints the ever-present New England barn. There it is, as large as life and twice as handsome, smack in the middle of the canvas.

My advice here is either to make the house or barn so large that only a *part* of it shows, or put it back in the middle distance—not in the center—so that the eye of the viewer can move easily to the building after entering the landscape.

Another way to do a barn subject is to do a closeup—say, just a door or perhaps a cobweb-covered window. This approach has become so popular with all the Wyeth imitators that it's beginning to get a bit tiresome. But doing it well is all a matter of composition and how you design the space.

To give your painted house or barn a feeling of solidity and the illusion of reality, you must keep the light direction in mind and make use of light and shade to model the form of the building. Also, get some cool color into the shadowed side and make the light parts warm in color. For instance, the boards of an old weathered barn could be a warm gray in the light, but in the shadows, facing away from the light, some blue or violet could be introduced.

The brushwork best suited to old barn boards is the scumble. This is demonstrated in Figure 17.

Perspective plays a fairly important part in the drawing of barns and houses. The landscape painter need not know as much about it as the architect, but he should learn the elementary principles. These can be found in any textbook on drawing. The most important principle for landscape painters is this: all parallel lines appear to converge toward the horizon or eye level. It's the only one I really know. The other principles I've learned through observation and a bit of thinking.

Water

Sometimes beginners ask: "How do you paint water?" After they've been painting for a while with a competent professional teacher, they realize that this is a pretty dumb question. One lady, who should have known better, once asked me, "How do you paint rope?" Well, there's no formula for painting *anything*—water, rope, or anything else. The landscape painter isn't a painter of things, but a painter of light. The "thing" being painted is of secondary importance. However, lakes, ponds, and brooks do occur in landscape, so a few hints may not be out of place here.

In the open, water gets its color from the sky and from reflections of nearby

Figure 14 *Scumble is a useful technique for obtaining textures. You simply drag a brush well loaded with paint over the dried surface where the textured effect is desired. It can be used to paint a light color over a dark, dried color, or a dark one over light.*

Figure 15 *Weeds and grasses are suggested here by scratching the thick, wet paint with the point of a palette knife.*

Figue 16 *Spatter work can sometimes be used to suggest weeds or wildflowers. You can spatter dark over light or light over dark. Here I've used the latter. To do this, it's best to put your canvas flat on the floor or table. Hold a brush in a horizontal position over the area you wish to spatter. Then with a second brush loaded with paint, you tap the handle of the first brush causing the paint to fly off the second. You see here the spattered white dots (left) and I've also added a suggestion of stems and leaves (right). These were done with a small, pointed watercolor brush.*

trees, hills, houses, etc. Reflections are mostly the color of what's being reflected. A yellow-green tree will have a yellow-green reflection, not a blue one, as many of my students seem to think. One of them actually painted a dark blue reflection from a red boat! Just remember that the water acts as a mirror, that's all. In shallow ponds, of course, the character of the bottom will have some influence on the color of the water.

Use mostly vertical strokes when you're painting reflections, then cut across them with one or two horizontal strokes to establish the plane of the water (Figure 18). This last can be done as a scumble if you want the effect of sparkle on the water.

Light and atmosphere

Keep light and atmosphere in mind at all times. Certainly, there are objects to be painted, but don't think "things." Think of light, tonal values, and shapes. Without light, your painting is a dead thing. Without correct tonal relationships, there's no illusion of reality, and unless the big, main shapes have been organized to create a good abstract pattern, your composition is a failure. These are the important *things* of landscape painting, and every student should think constantly of them.

Is there a difference between morning and afternoon light? Not a great deal, in my opinion, although there is some. If you are enjoying the sunset from or near a large city, which has been 'filling the atmosphere with pollutants all day, the light will be different because you see it through layers of grime. During the night some of the smog will settle; the morning light will be clearer but never as clear as a sunrise or sunset far from the city or over the ocean.

Sunrise is apt to be cooler in color than sunset. There will be some warm color, of course, but also look for those cool violet tones (Figure 19). About sunsets, nature's spectacular, my advice is "don't paint 'em."

Skies and clouds

Sky painting is mostly memory painting because nothing is standing still up there. If clouds are present, they have perspective and aren't just round or oval patches of white on a flat field of blue. You don't have to be a meteorologist, but if you're going to paint landscapes, you should be familiar with the characteristics of the different types of clouds.

The cumulus cloud is the most impressive cloud in the sky, also one of the most difficult to paint (Figure 20). This handsome, towering cloud which at one moment suggests castles, and at the next, mountains, seems to move faster than most.

Storm clouds, or stratus clouds, are usually flatter in shape and seem to move more slowly. With their edges all ragged and torn, storm clouds are best painted swiftly, then left alone (Figure 21).

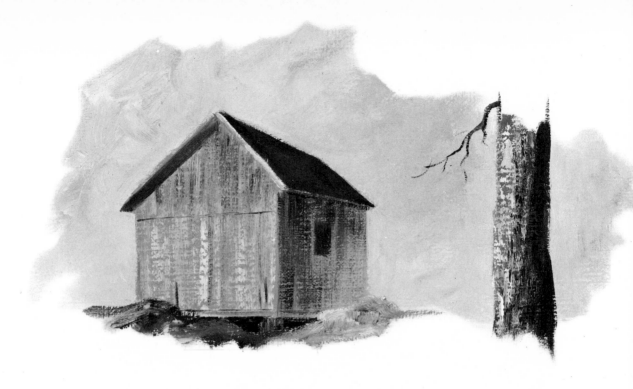

Figure 17 *Scumble can be used to suggest the texture of old weathered boards (left) or the rough bark of some trees (right).*

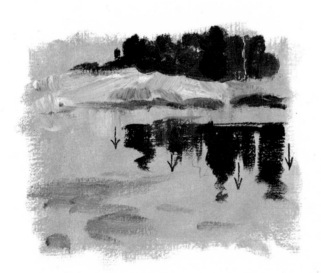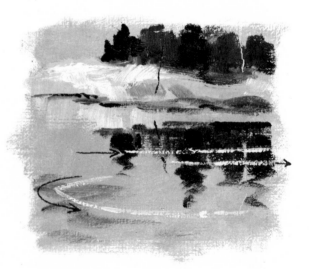

Figure 18 *Beginners often have trouble establishing the plane of a body of water such as a pond or lake. It can be done quite simply by painting reflections with mostly vertical strokes (left), then cutting across the reflections with some horizontal lines (right). This not only makes the water look more like water but keeps it from standing on end.*

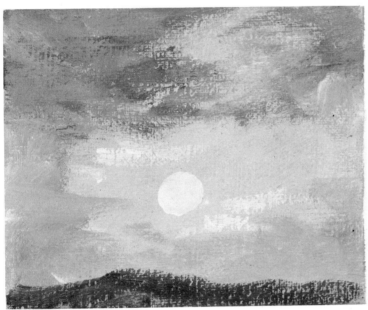

Figure 19 *I'm sure no one will ever be able to discourage the amateur from painting sunsets. So if you must do it, here's a procedure that may keep you from committing another "fried egg in the sky" kind of thing. I first pre-tone the canvas with a thin wash of cadmium orange, wiping off all the surplus with a rag. Then, I paint in the glow surrounding the sun. This is done with mixtures of cadmium yellow light, cadmium orange, and white (top left); I place the actual orb of the sun using cadmium yellow and white. Then, with colors I seldom use for landscape work such as alizarin crimson and thio violet, along with cadmium red and orange, I start designing the cloud formation around the sun. At this time I would also start laying in my land areas, keeping in mind that with a low source of light, these areas will have long shadows as well as dark tones, rich in color. That completes the second step (middle panel). The final step (bottom left) consists of putting in the darker clouds using fairly cool color to contrast with the warm tones already used. The last touches are the lights reflected on the cloud's edges. So go ahead and paint sunsets if you must, but I wish you wouldn't.*

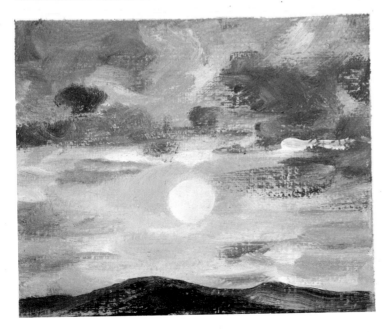

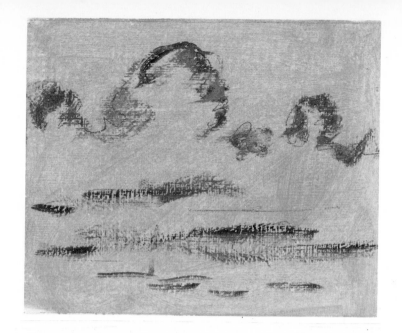

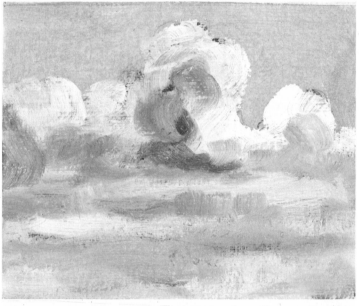

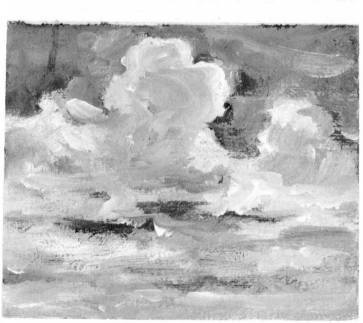

Figure 20 *First I give the sky a long thoughtful look and when the right moment comes along I quickly dash in a rough outline of a cloud formation that suits my composition. This is done with a little burnt umber thinned with turpentine or gel medium (top right). By the time I've finished this, the cloud pattern has changed but I must stay with my first impression. In the middle panel I lay in the cloud's light and shadow. The light parts I paint with white, warmed with a touch of yellow ochre (middle panel). The shadows are warm and cool grays obtained with mixtures of cerulean blue and cadmium orange. Keep the sky's perspective in mind; clouds should diminish in size toward the horizon. Now for the final step (bottom right), I paint the blue part of the sky around the top of my cloud formation and in some areas around its base where the sky shows through. For this I use a loose mixture of cerulean blue, white, and a little cadmium orange. The blue of the sky must have life—some vibration. It should never be a flat, blue backdrop hung up behind the clouds. I model the the form of the clouds, trying to give them some solidity, while at the same time retaining their luminosity. On days when this kind of sky occurs, I complete it before going ahead with the landscape.*

Figure 21 *Storm clouds, with their edges all ragged and torn, are best painted swiftly and left—never overmodeled. If you don't get them right the first time, scrape them out and try again. Here I first paint the background tone over the entire panel. Then with a large, flat bristle brush well loaded with my dark tone, I paint in the clouds as rapidly as possible. Swift brushwork best describes the character of this type of cloud.*

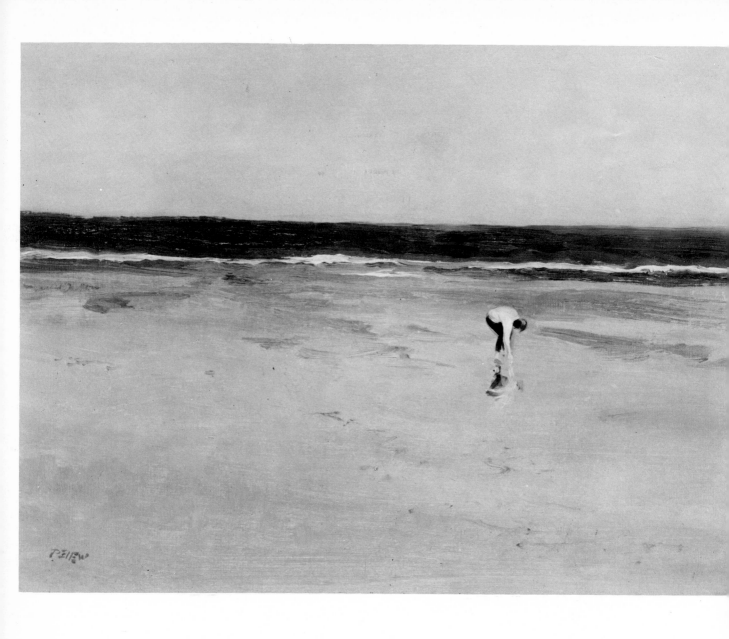

THE SHELL GATHERER, oil on canvas panel, 9″ x 12″.

These very simple statements are often the most difficult to do. I tell my students again and again to keep their work simple. Some of them heard this so often on a recent painting trip they started using a catch phrase of their own: "Keep it simple, stupid." The locale of this painting is Ogunquit Beach, Maine. It was painted in October when Elsie and I had the beach to ourselves. The golden girls and the girl watchers had all returned to their schools and jobs leaving the beach to the gulls and wandering painters. This is a "looking straight out to sea" type of composition. The three areas—sky, ocean, and sand—must be very carefully designed. You'll notice I've made them each different in size. This is important. Any landscape made up of several areas equal in size and importance can be dull and static. This picture is quite thinly painted, but not so thin that it lacks surface quality. Small figures such as my shell-gathering wife should be as simply painted as the rest of the picture. If overworked, such a figure will have a cut-out appearance.

Painting the shore

I WAS BORN within sound of the sea and I've lived all of my life on the coast, yet I've seldom painted what could be called a typical marine. By typical marine I mean that painting where the surf is breaking, or about to break, on a rock in the left or right foreground. That kind of marine painting, to be any good, is a job for the specialist; I'm too interested in the many faces of nature to paint one subject over and over. Anyway, no one has done it any better than Winslow Homer, although many try.

It takes a great deal of experience, and a lot of spoiled canvas, to learn the anatomy of waves and surf. Unless you live near the ocean and have the opportunity to study it every day under all kinds of weather conditions, suppress your longing to be a marine painter.

But don't be discouraged. There's a lot of subject matter for the vacation painter along the shore. There are boats, harbors, and beaches—all good subjects.

Painters from the Midwest find the lighthouses along our New England coast very attractive. And so they are. Because most of these lighthouses are old, they're quite interesting in design. I once spent a week on Cape Ann, Massachusetts, with a group from Ohio who seemed happiest when painting lighthouses. I suggested that they change the name of their art society to "The Lighthouse Painters of America." They laughed and then went looking for still another lighthouse.

Avoid the obvious

A word of caution: when looking for a subject by the sea, don't be trapped by the obvious, the scene that's been painted so often it becomes a bore. If you come from somewhere inland, be careful; you could easily be captivated by your sudden exposure to boats and ocean. Don't let the salt air go to your head.

Remember, that Gloucester fishing boat tied at the end of the wharf, with those cute, wiggly reflections in the water, has appeared in hundreds of galleries and, maybe, on thousands of calendars. The breaking wave on the rocky coast of Maine is another trite subject; unless it's very well done by an expert, it's bound to be a dud.

Painting the beach

Then, what should you paint? Well, the beach has much to offer. In the summer there is a streach of sand, a bit of blue ocean, and some simply suggested figures in brightly colored beach attire.

That's all that Eugene Boudin ever had and look at what he did with it. His beach paintings, broadly and simply stated, are charming and beautiful little masterpieces. Let's not forget the two great beach sketches of John Constable: *Weymouth Bay* and *Brighton Beach, with Colliers.* All students of outdoor painting in oils should study the work of these two great pioneers of landscape art.

I'm fond of the beach in autumn. There are few people about, or none at all. No one has been around to tidy up the sands. A late season storm has left driftwood and dark patterns of seaweed strewn along the high water line. See my *Good Harbor Beach* on page 65.

When you're painting on the beach, I think it's best not to look straight out to sea. When you look along or down the beach, you can avoid the repetition of parallel lines formed by beach, ocean, and sky that occur in the straight-on view. I don't say that you should *never* look toward the sea, but consider the other way first.

A beach painting calls for a very careful study of tonal values. On summer and autumn days, you'll have a high keyed picture due to the great amount of reflected light present. There won't be any dark shadows. However, the sand is seldom as light as the beginner usually paints it.

A device for testing tonal values on the beach is simple to make. It consists of a piece of cardboard, a little larger than an ordinary postcard, with three holes in it. You hold up the card so that you see the sky in the top hole, probably the water in the center, and the sand in the bottom hole. All you see are spots of color without form. You discover that the sand you thought was so light is actually darker in value than the sky. The correct relationship of tonal values is of the utmost importance—this is a fact that the student should get fixed in his mind forever. When the values are correct, there's a feeling of rightness about a picture. When they're false, there can be no true feeling of reality. I repeat this to my students over and over and will do so in the pages of this book. Believe me, it's important.

I think the painting, *St. Ives,* reproduced on page 145, is perhaps the most successful harbor picture I've ever done. It's broadly painted, and I think the fact that the tide is low, with the boats aground, saves the picture from being commonplace. The large area of wet mud and sand, with its reflecting puddles of water, gives me a chance to use thick, rich pigment and broken color. I'm sure the harbor would be less interesting at high tide when it's full of water.

Broken color

This may be a good place to explain broken color—or at least what I mean by broken color. There are two ways of obtaining the effect which can be described as a mingling (rather than an actual mixture) of two or more colors—some warm and some cool.

One method is to drag or scumble a cool color over a passage painted with a warm color, or vice versa. The other way is to dip the brush into a warm and a cool tone, mix them loosely on the palette without really blending them, and then apply the brush to the canvas. The intermingling threads of warm and cool set up a vibration and are mixed visually—by the eye—from a normal viewing distance.

There's a great deal of broken color in *St. Ives,* and also in *Bass Rocks* on page 74. In both, I make use of broken tones obtained by loosely mixing cerulean blue, cadmium orange, and white. If the colors are more thoroughly mixed, good grays can be obtained.

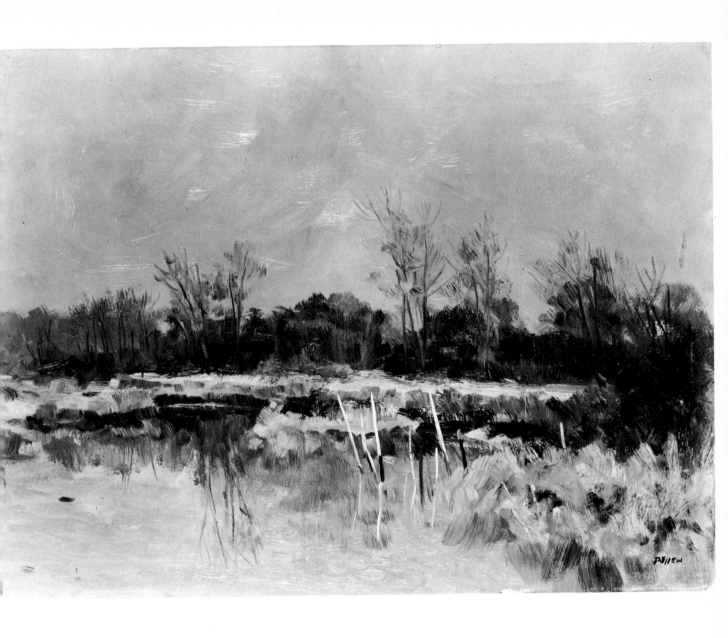

AUTUMN HAZE, oil on gesso panel, 12″ x 16″.

Light can transform even a dismal swamp into a thing of beauty. It certainly happened at the place pictured here. It was Thanksgiving Day and very warm for November in New England. I drove toward the shore with a beach painting in mind. The road borders some swampy land that I'd seen often but never thought interesting enough to paint. The sudden warm spell had created a humid condition. As I came out onto the swamp road, I saw that there was a thick haze over the marshes through which the sun was trying to shine. The effect was delightful. There was a kind of subtle magic in the atmosphere. What I'd seen other times as a stark dismal place was now a delicate poem of light and color. I never reached the beach that day. This was the kind of thing the landscape impressionist prays for and so seldom gets. In a very short time I was set up and at work. Most of the colorful grays in this painting are combinations of cerulean blue and cadmium orange with white. Being loosely mixed, evidence of the warm orange and the cool blue can be seen mingling throughout. This warm and cool color contrast is called "broken color"—a useful technique for the type of light and atmosphere present that day.

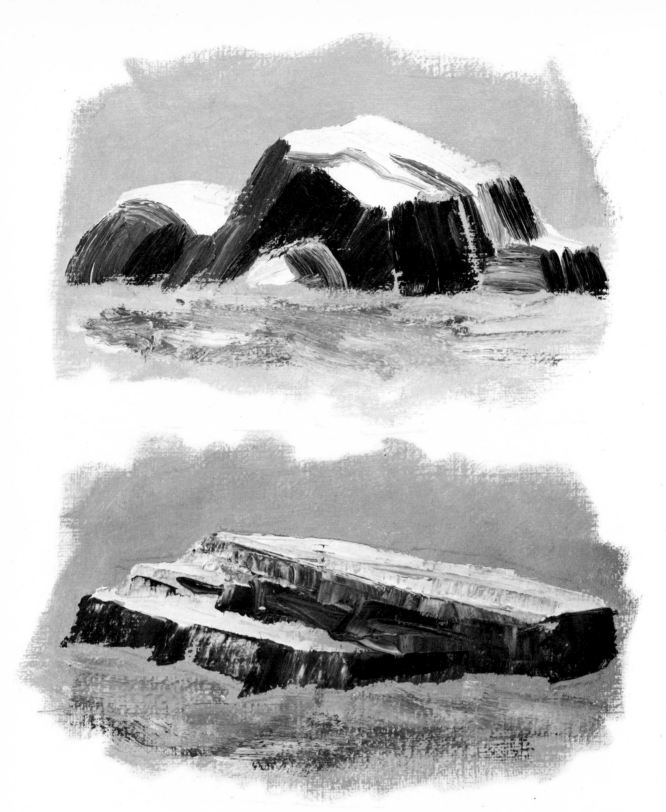

Figure 22 *These two rock sketches demonstrate how form or the illusion of solidity can be attained. The first sketch (top) was painted throughout with the brush, the second (bottom) with the palette knife. In the first, broad brushstrokes follow the form of the rock—horizontal strokes on its flat top and vertical strokes down its sides. The feeling of solidity is heightened by the strong top light and the darker tones used for the sides. In the second sketch, a flat ledge-like rock, the paint was laid on in long horizontal bands with the knife to suggest the character of this type of rock. Here you also see the strong top light and the dark sides.*

The right point of view

I think *Bass Rocks* proves my point about avoiding the obvious. The student or amateur would probably go much nearer the water, and the result would be just another surf and rock picture, the kind that's been done better by you-know-who. In selecting my point of view, notice that I choose a spot where an area of small pebbles, rather cool in color, wanders like a path up through the picture's center, and is flanked by large rocks to the left and right, mostly warm in color. This path-like pattern leads the eye to that glimpse of distant ocean. To prevent the movement through the center from becoming too rapid, the dark bushes are placed at the top to act as a brake.

You may ask whether much of this is carefully planned before I start painting, or is a lot of it a happy accident? The selection of a good point of view is never accidental. However, I'll say that I think a great deal of it is intuition—with me, at least.

Quickly seizing the right point of view comes from long years of practice and experience. Five minutes after walking from the road over the rocks I was setting up my gear at this spot. No, I don't believe I analyzed the pattern as I've described it above, but something told me it was there and it was right.

Painting rocks

I've demonstrated rock painting with brush and knife (Figure 22). What else is there to say about rocks? Remember, they are very solid things and should look so in a painting, no matter how simply treated. Don't paint soft, mushy rocks. A rock, like a box, has a top and sides. The top, facing up to the sky, will be lighter than the sides.

What colors should be mixed to paint rocks? That's almost impossible to answer. Along my stretch of the East Coast, from Connecticut to Maine, I have seen rocks that range from almost white to quite black; in between there are yellow ochres, browns, blues, and all shades of gray. No, I can't give you a recipe for rock color—even rocks change color. A blue-gray rock could be a warm violet at sunset, and a pale yellow one might be orange at that time of day. So again, I say there's no formula. Use your eyes and think. Don't be like the beginner that asked the man in the art store for a tube of flesh color, or was it rock color?

When painting rocks, model the form with the direction of your brushstroke. Rocks can be simply stated with few strokes and broad planes of color, but the rocks should convey an illusion of solidity. On a sunny day, their tops (facing the sky) will be lighter than the sides. Always remember that anything horizontal that's facing the sky will be lighter in value than anything on a vertical plane. For instance, a shadow cast upon the ground will be lighter than the vertical object that casts it, because the shadow on the ground receives a great deal of reflected light from the sky. Keep your shadows luminous; avoid blackness.

What do I mean by luminous shadows? I simply mean colorful shadows. In nature, all shadows have color. Many beginners think shadows are dark areas that can be obtained by mixing black paint with the local color of the rock or whatever else is being painted—not so. Black is the absence of light; outdoors there's always light. A shadow cast upon the ground and facing up to the sky will receive a good deal of cool light reflected into it from the sky. However, a perpendicular wall not getting as much light from above could, under some circumstances, be fairly cool in color at the top, but its base might be much warmer in color due to reflected light from the ground. This cool to warm gradation is

COMMERCIAL PIER, oil on gesso panel, 9″ x 12″, collection of Mrs. Fran Hurlburt.

I rather like this painting in spite of the fact that I've broken all the rules of composition. I've done the two things I tell my students they should never do. The horizon line is too close for comfort to the center of the picture's space, and the fishing boat and dock divide the space vertically through its center. O.K. I did it—no excuse. It only proves that anyone can make a mistake. However, because I think it has some redeeming features, it appears here. I like the color—there's a rusty red on the boat surrounded by all kinds of grays. Some grays are warm, others cool, some brown, and some gray-green. That bit of red that reflects in the water doesn't do any harm either. Yet, it's now quite the usual Gloucester fishing boat picture. I wonder why? Maybe it's because it's not too well composed.

Long Island Dunes, oil on watercolor paper, 11½"
x 7½".

*I advise students to look along the beach. It's better
than looking straight out to sea. The head-on view
of ocean and sky is more difficult to compose be-
cause the subject is made up of three horizontal
bands—sand, water, and sky. These should never be
equal in size. Let the sky dominate or make use of
a lot of foreground sand. However, when you look
along the beach, rather than straight ahead, there's
always something to contrast with the flat pattern
of sand, water, and sky. In this painting done at
Jones Beach, Long Island, the verticals of the sand
dune and post at the left break the horizontal pat-
tern. It was a breezy day with cloud shadows creat-
ing beautiful light and dark shapes on the sand.
When painting these shadows at the beach, remem-
ber that there's a great deal of light reflecting
into them from the sky. Keep them luminous; they
aren't as dark as you think. The two small figures
add an extra note of bright color—one red, the
other yellow—against the dark blue ocean.*

sometimes seen on tree trunks. When a deep, dark tone is needed, it's far better to mix it rather than to resort to black paint. Such a color, obtained with a mixture of alizarin crimson and thalo blue, will be just as dark but have more life to it than black paint.

The color of water

Pick up a glass of sea water. It has no color. Where, then, does its color come from? Deep ocean water gets its color from the sky. On a clear, bright day, the water will be blue. On a gray day, it's gray. Harbor water, if it's shallow at low tide, will get some of its color from the bottom mud or sand, and some from the sky.

Reflections of boats, docks, and other solid objects all lend their colors to that of the water. Don't forget: reflections are mostly the color of what's being reflected. A white boat won't have a dark blue reflection. Think that's funny? I've seen it done—more than once.

Sand dunes and salt marshes

What else along the shore can you find to paint? Well, there are sand dunes. The mistake most often made by beginners in painting this subject is a failure in composition. They place one dune at the right, another at the left, and between them a bit of the ocean, smack in the middle. Again, that's being trapped by the obvious. Why not look *along* the dunes as I did when I painted *Long Island Dunes* (page 63). If you must look out between the dunes at the ocean, keep the ocean out of the center of the picture and don't make the dunes equal in size or importance.

To keep that bit of ocean flat—to avoid having it look like a blue wall—establish its plane by means of a gradual color change from dark at the horizon to lighter near the shore, or vice versa.

The most luminous shadows of all are those on the beach and on sand dunes. They can be quite cool in color because there's nothing but air between them and the blue sky above. For the same reason they will be very light in value.

Sand dunes painted by students are often too yellow in color. Actually dunes are seldom, if ever, yellow. The sand is really a variety of warm and cool grays. In beach pictures I find that grays obtained with white, cerulean blue, and cadmium orange are the most useful. The more blue you add to the mixture, the cooler the gray will be; if you add more orange, it becomes warmer. If you are in doubt about the color of sand, cut a hole the size of a dime in a piece of cardboard, look through it at the sand, shutting out all else. All you see is a tiny patch of color that will probably be much grayer than you thought it was.

Along the eastern coast of the United States, there are many salt marshes. They've always been one of my favorite subjects. In case you're not familiar with a salt marsh, it's a low-lying tract of land along the shore, mostly flooded by the ocean at high tide. The parts above water are covered with a tall, coarse grass called salt hay. The "old timers" harvested it. There are some nineteenth-century paintings that show them hard at it.

Marsh scenes are best composed with a low horizon. That's the way the old Dutch painters did them, and so did the Englishmen who painted the marshes of Norfolk. Be careful not to paint an equal amount of sky and land. In other words, watch out for that central division of the picture's space.

(continued on page 83)

GOOD HARBOR BEACH, oil on gesso panel, 12" x 16".

This is a favorite spot at Gloucester, Massachusetts. Most people go to the beach in the summer; I go in the fall. After Labor Day our northern beaches are almost deserted. It's a great time to be there with your feet in the sand and the sound of the surf in your ears. This picture is a quick sketch painted after I'd completed a 16" x 20" sketch looking in the opposite direction. The moment I turned around I saw how beautiful this view was in its subtle color and tonal values. It had to be painted, and in less than half an hour it was. Notice the high horizon well above the center of the picture space to avoid dividing the composition equally between sky and sand. The figures, though small, are the point of interest because the dunes at the left and the surf on the right lead the eye to them. This is also true of the dark squiggles on the sand starting from the left foreground. The distant headland, although backlighted, needed simplification because of the many summer cottages on it. They do nothing to enhance the beauty of this lovely coast, so I reduced them to a few square brushstrokes, retaining the color and value of the whole without all the disturbing detail.

NATURE TRAIL, oil on gesso panel, 12" x 16".

I've done a lot of painting in the grounds of Westport's Youth Museum. This picture painted a couple of years ago is one of my favorites. It was done from the trail looking across a small pond. I always find woodlands thrilling in the month of October. This particular woods is doubly interesting because of its ponds and the stream running through it called Stonybrook. There's really no beginning or end to this composition. It's an all-over mingling of warm and cool color with a pattern of vertical and horizontal lines representing trees, fallen branches, and reflections. Until I'd put in the treetrunks and the horizontal fallen branch, the picture was a tapestry-like abstraction with little or no feeling of reality. This has been my usual procedure when painting the interior of a woods. I established a pattern of color and tonal values that I considered a good design. When this was completed, I put in the treetrunks, branches, etc. I placed them where I felt they'd do my composition the most good, not always where they really were in nature. A few (very few) final touches with a small brush—in this case the cluster of light yellow leaves in the center—and the picture was finished.

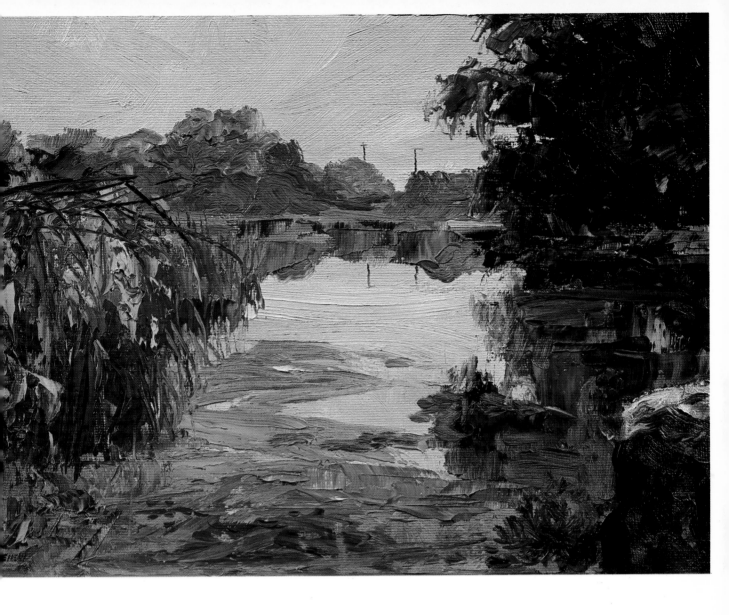

VIEW ON THE SAUGATUCK, oil on gesso panel, 9" x 12".

It's said that an artist paints best the thing he knows best. If true, this should be one of my better paintings because it's a scene I've looked upon almost every day for the past fifteen years. I've painted a great many sketches up and down the Saugatuck River at all seasons of the year. It often reminds me of some of the subject matter painted by Monet and the other impressionists—especially in the early morning. River banks have always attracted painters and this rather small, unimportant river in Connecticut is very attractive. Study my thick, rich paint application which I think is suited to this type of subject. Note that the paint is thickly applied throughout. I think it's important to have the same kind of surface over the entire picture. This is called paint quality, or sometimes, surface quality. When painting landscapes, I don't hold with the theory that shadows should be painted thin and lights thick. A Monet landscape has the same thickness of pigment throughout, as do landscapes by Sargent and the great Maine seascapes of Homer. The sky and water in this were painted with the brush, most of the remainder of it was painted with the palette knife.

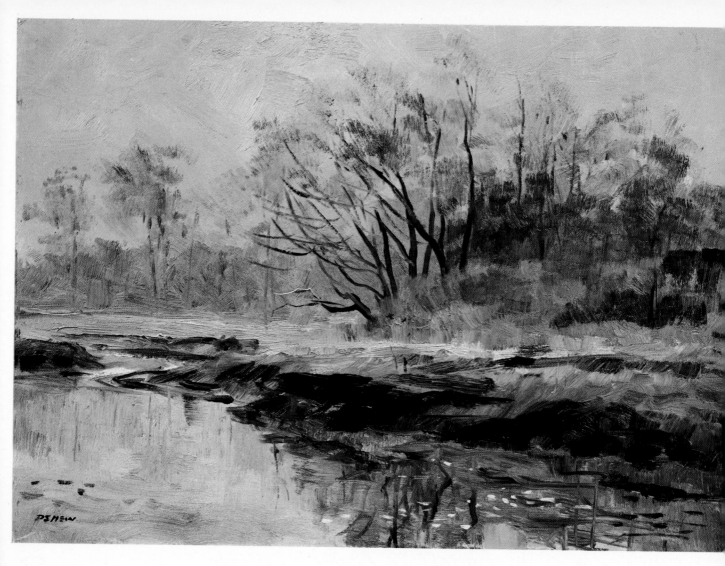

(Above) A GRAY DAY, oil on gesso panel, 10" x 14".

The kind of day we call gray isn't really lacking in color. The color is there but toned down by the moisture in the atmosphere; it's subtle color. Some students are afraid of gray days. They think the color subtleties and close tonal values are difficult to paint. I don't go along with that. I think a bright sunny day can be the more difficult of the two. On a gray day the curtain of mist makes a definite separation between foreground, middle distance, and distance. Each is different in value: the darkest value is in the foreground, and the lightest in the distance. These distinctions aren't so clear on sunny days. Then the landscape painter has trouble creating an illusion of depth. This is especially true of mountain country where the atmosphere is so very clear. This picture was painted in early April; the buds were beginning to fill in the twig masses. I would call this a mood picture. A landscape painting means little to me if it doesn't express a mood of nature.

(Right) VISIT TO MUCKROSS, oil on gesso panel, 10" x 14".

This painting of Muckross Abbey was done from an acrylic sketch made on the spot as a demonstration for a group of fellow artists. During my painting trip to Ireland I saw many old churches, castles, etc. However, this was the place I liked the best. Being a ruin, there was no roof, and the light from the sky illuminated the interior. The old stone walls washed by the rains had an almost bleached appearance. The dark green trees beyond the far window created a good tonal value contrast with the well-lighted interior. Avoiding a tendency to overwork the texture of the stone walls was a problem. Although this is a small picture, I think the contrast between the tiny figure and the towering building creates an impression of the great size of the interior. My model was artist Nancy Wostrel of San Diego, California.

NEIGHBORS, oil on gesso panel, 15" x 19".

Here's the edge of the woods a few yards behind my home. I remember I'd gone out to the studio to work on a picture that wasn't going too well. Looking out of its east window, I saw a lovely burst of morning light streaming through the trees. This kind of thing really excites me and in less than ten minutes I was outside and hard at it. One lesson to be learned here is that the landscape painter should always have painting gear easily available. Except for the tree-trunks and the figures, most of this picture was painted with the palette knife. I started by laying in the lightest areas, then followed with the middle tones. As usual with my woodland scenes the treetrunks were the last to go in. With a well loaded brush, they were dragged downward through the thick, rich pigmentation of the foliage. To be truthful the trunks weren't the last things painted, the figures were. I hadn't planned to use figures in the composition but my daughter happened to walk by, so I thought, "Why not?" Besides, by adding a second figure I had an excuse for a nice title, and I love a good title.

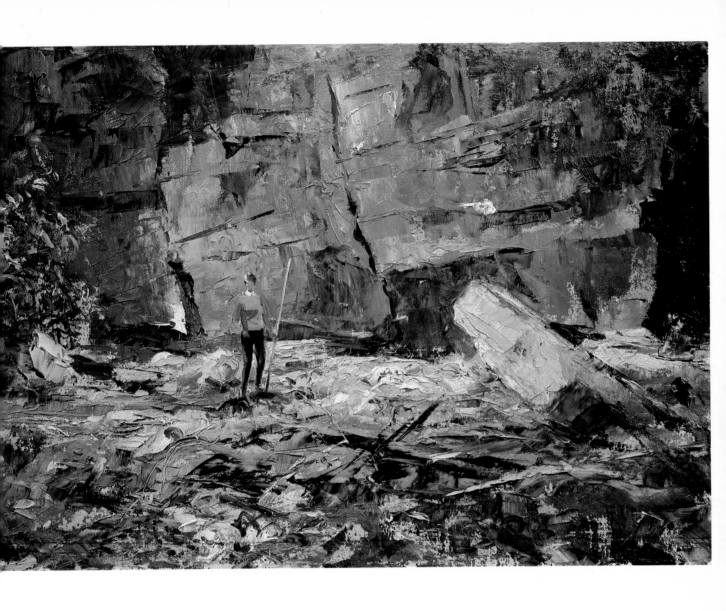

COLORADO CANYON, oil on gesso panel, 14″ x 20″.

In mountain country there are many subjects—you don't have to paint just mountains. The wall of red rock was a nice change from the mountains and ghost towns. In this type of subject, which is kind of a closeup, it's often difficult to establish depth and scale. Only by including a figure is it possible to get an idea of the size of the place. The large upthrust rock in the right foreground also helps. The foreground was a mass of fallen rock and a jumble of dead branches left by the spring floods that roar through the canyon when the snow melts. When I was there in August, it was a quiet stream that hardly showed any signs of movement. Except for the figure, this picture was painted throughout with the palette knife. I first covered the panel with a warm tone of burnt sienna mixed with a little white. The cool shadow tones of the foreground acted as a complement to the warm reds of the canyon walls. As usual the figure was the last thing painted.

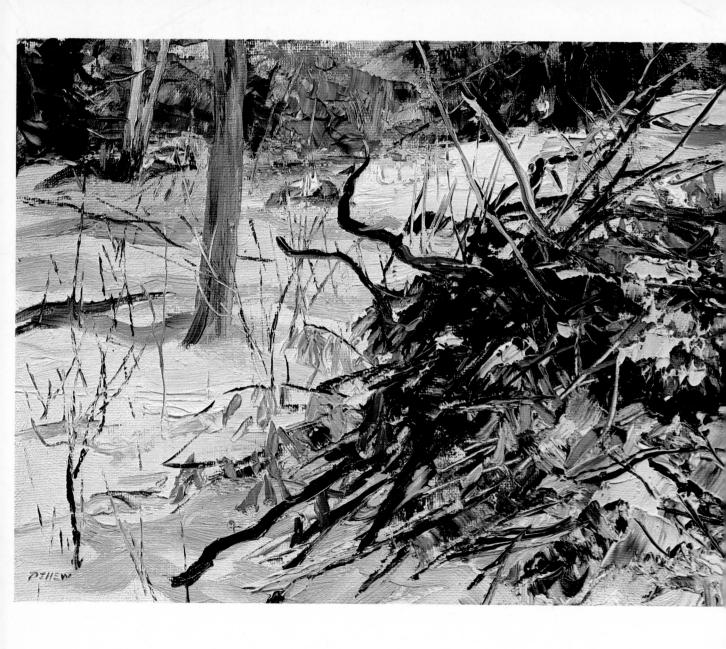

WINTER BRUSH PILE, oil on canvas panel, 9" x 12".

*A few years ago I built a large brush pile in the woods behind the house.
I wanted to provide a refuge for the birds and small animals that spent the win-
ter with us. My patch of woods has been the source of a lot of painting subjects,
but I never dreamed that the old pile of brush would be worth turning into
a picture. Yet, there it was sparkling in the sun one morning in January. The
snow that had completely covered it earlier had partly thawed, revealing a tangle
of twigs and branches with patches of snow between them. The browns and
grays of its wood contrasting with the ochres and faded reds of last autumn's
leaves, plus the cool blue of the snow in shadow, created a rich tapestry of color.
It had to be painted. This little panel is loaded with paint, most of it applied with
the palette knife. I started at the top with the distant trees; then the snow was
put in. Over this went the brush pile, first using the knife, then a pointed round
brush for twigs and branches. You may also see where some were scratched out
with the knife's point. I was ready for hot coffee by the time I was finished.*

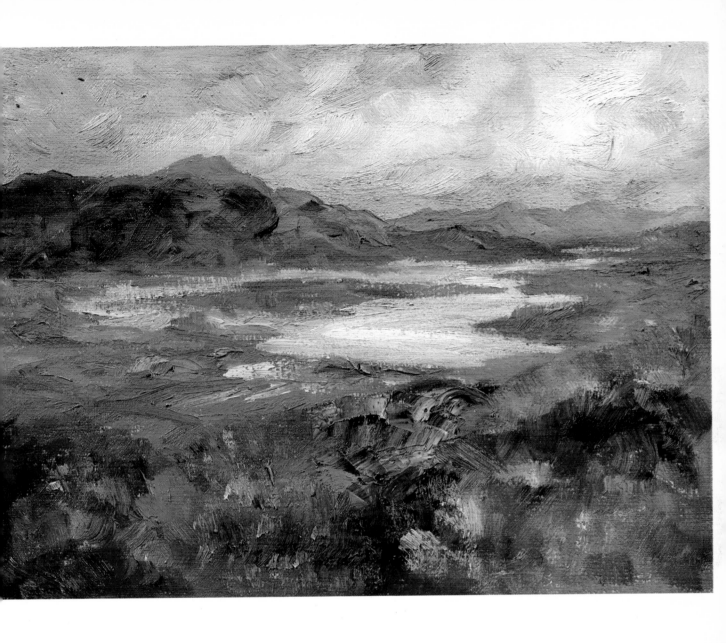

RING OF KERRY, oil on canvas panel, 9″ x 12″.

Every visitor to southern Ireland should go around the Ring of Kerry. It's a day's circular drive of roughly a hundred miles. The scenery is magnificent. There are peat bogs and small farms with those tiny hedged fields that give Ireland the forty shades of green that the song boasts of. There are lakes and mountains, little villages in picturesque settings, wide bays, and towering cliffs. Then, there's the charm of the place names that are never to be forgotten—Dingle Bay, Ballinskelligs Bay, Valentia Island, and Kenmare River. I was the artist instructor for a Painting Holidays group in southern Ireland. We sketched our way around the ring one day and a delightful day it was. The people we met and talked with along the way were charming and most interested in what we were doing. One place I saw but didn't paint while there was the view overlooking the Killarney Lakes. We made a very short stop just to look down the valley. It was long enough to register the scene in my mind. It must have been a powerful impression because I kept remembering it for the rest of the trip. What to do to get it off my mind? Well, there's only one thing an artist can do—paint it. So a month later in a Connecticut studio I painted this picture from memory.

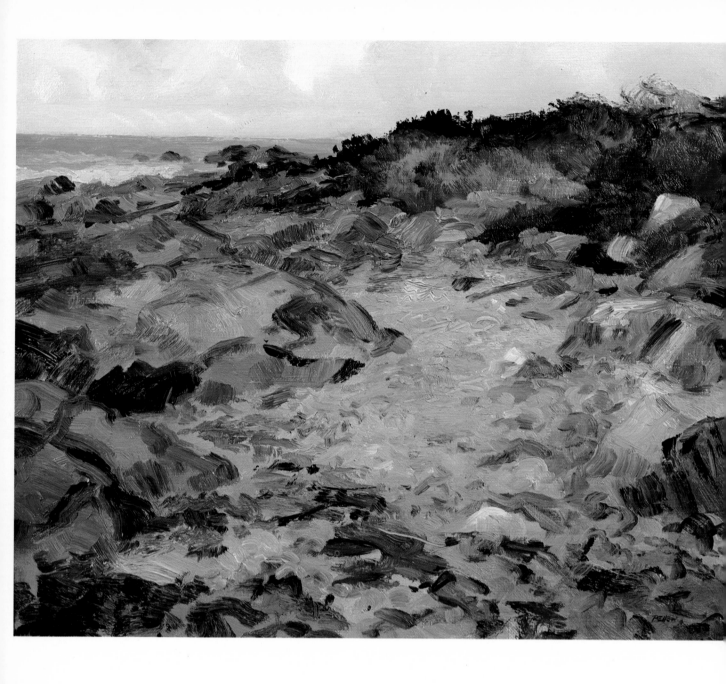

BASS ROCKS, oil on gesso panel, 16″ x 20″.

This stretch of rocky coast betwen Gloucester and Rockport Massachusetts is truly beautiful. Even the modern motels and summer boarding houses lining the coast road cannot dim its majesty. It's a favorite haunt of marine painters, especially after a storm when there's a good surf pounding the rocks. There's very little ocean showing in my picture. In Chapter Six I've told why. I'm not a "breaking wave" specialist. There's so much interesting material along the shore, that it hardly seems necessary to paint the obvious—that everlasting, pounding wave. The warm and cool tones of this picture were mostly mixtures of cerulean blue, cadmium orange, and white. There's a good deal of broken color obtained by very loosely mixing the colors together on the palette and placing them on the panel in an unmixed state. If the colors were thoroughly mixed, a gray tone would result. Because the mixing isn't complete, the brush leaves a woven pattern of warm and cool color that sets up a vibration, an illusion of luminous outdoor light.

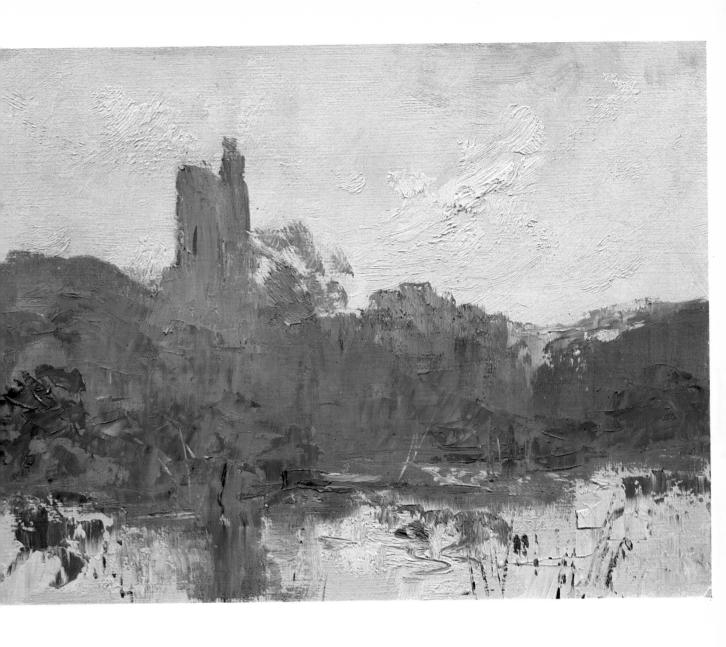

ROSS CASTLE, oil on gesso panel, 9″ x 12″.

It's fun to dream and fun to paint a dream. That's what this is, a picture of a dream. When I was in Ireland I painted a watercolor of Ross Castle near Killarney. I find that the mere act of looking at a place long enough to make a fair representation of it on paper fixes it in my memory. Of course, there were other things that have kept that first day in Ireland fresh in my memory. The ride out to the castle in a jaiunting car, and the group of nice people that were with me are just two of them. What's all this got to do with the dream picture? Several weeks after I returned home, I dreamt I was back in Ireland at Ross Castle, but it was quite different than it had looked when I painted the watercolor. It was all violet, blue, and gold; it was lovely. I was getting out my paints by the time the dream ended. A few days before my dream, I had been telling an artist friend about the great Turners I'd recently seen in London at the Tate Gallery. Turner and Ross Castle had become mixed up in my dream and the result was a picture like nothing I'd ever painted before.

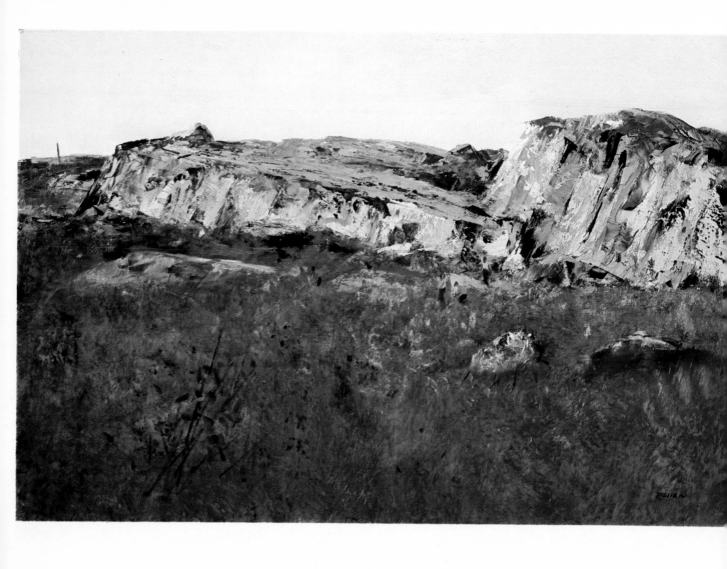

BLUEBERRY LEDGE, oil on gesso panel, 15" x 23".

*I painted this from a watercolor sketch made on the spot. October in Maine—
it's a marvelous time to be there. The land, covered with blueberry bushes show-
ing their lovely red autumn color, reminded me of the English moorland. The
rocky outcroppings of gray granite were a perfect compliment to the red color
of the foliage. There were still some berries left on the bushes when we were
there. Elsie, my wife, picked while I sketched. When I started the picture, I estab-
lished my composition with acrylics on pure white gesso, because I wanted to
make use of the underpainting in the foreground, the area containing the bushes.
With rubbings and scumbles of oil paint over the red underpainting, I obtained
a variety of tones suggesting detail without creating a rough textured surface.
I saved the rough, thick paint for the rocky ledge which was painted with the
palette knife. I believe this place is on Deer Isle, Maine, but I'm not sure. The
following year we made two attempts to find it but had to give up. The picture
is a good portrait of the place. If anyone knows where it is, please let me know.
I want to go back.*

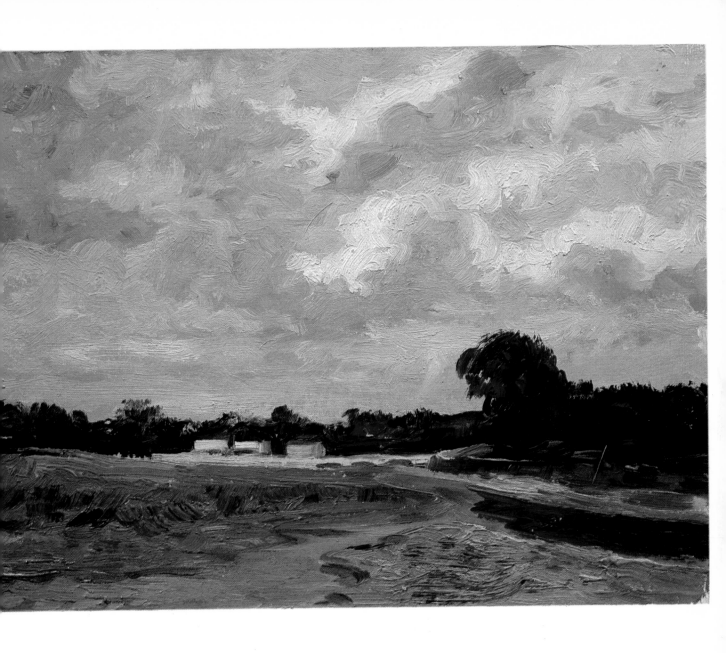

THE SUNLIT BRIDGE, oil on gesso panel, 9″ x 12″.

The bridge in this sketch marks the limit of tidal water into the Saugatuck River. Above it the river becomes a narrow, fresh-water trout stream. Because of the tide's action, the water is an ever-changing pattern of colors and shapes from the bridge to where the river meets Long Island Sound. This small painting reminds me of the English school of painters who have worked around Norfolk. The low horizon and partly cloudy sky is typical of their work. The country along the Connecticut shore is also reminiscent of their locale. There are many areas where our salt marshes have much in common with the Norfolk Broads. Days such as the one on which I painted this picture always delight me. The swiftly moving clouds cast shadows on the land which spotlight a small area one moment, then plunge it in shadow the next. It's a challenge to the landscape painter. The only way to capture it is to wait for a good effect to happen; then, with it fixed in your mind, paint it. Don't be influenced by what may happen later. Use the same system with the ever-changing clouds. Look for a good cloud pattern; then stay with it. Sure, this is working from memory. Isn't all landscape painting?

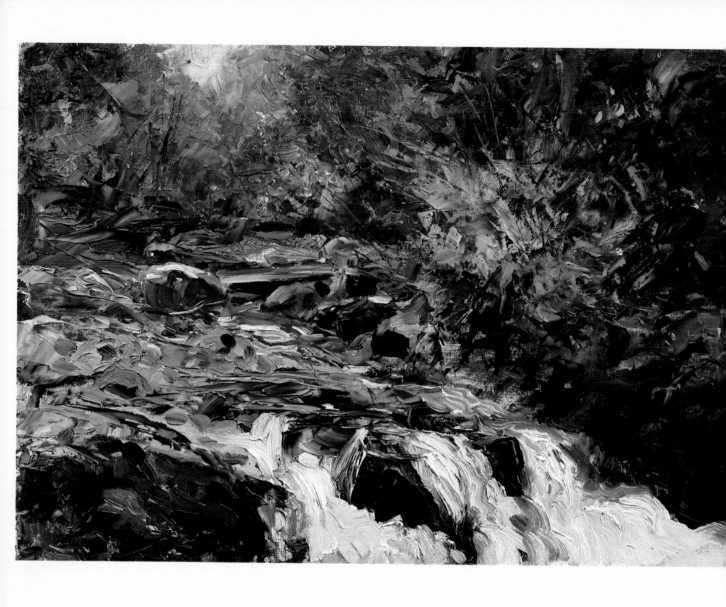

ON NORTH TWIN MOUNTAIN, oil on gesso panel, 14" x 19".

The Little River that comes down from North Twin Mountain has provided me with a lot of good painting subjects. There are other pictures of this stream in this book—older ones. This is more recent. When my daughter Elma was young we had to leave the mountains in time for the start of school but now I can go there in the fall as well. This was painted in October, in my opinion the best month of the year in New England. If there's any difference to be seen between this and my earlier pictures of the Little River, I think it's in the palette knife work. I don't think I would have had the confidence to use the knife to this extent twenty years ago. Here I painted dark over light and light over dark with reckless abandon. What finally emerged was a rich tapestry of color through which the water dashed over rocks and fallen treetrunks. In landscape painting nothing worthwhile is ever accomplished with timidity.

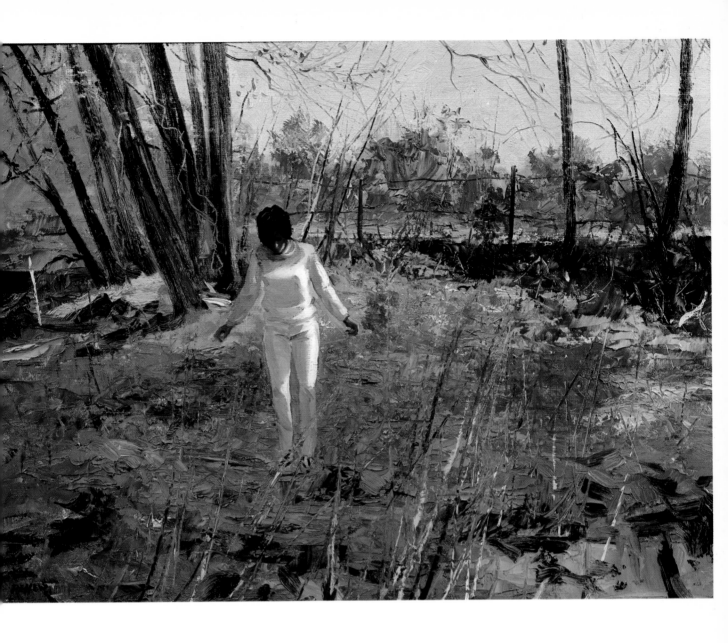

OCTOBER AFTERNOON, oil gesso panel, 12″ x 16″.

I guess I'm partial to autumn scenes. It seems that I paint more of that subject than any other. In the fall the painter is no longer troubled by the monotonous greens of summer. The foliage takes on a great variety of warm colors. Note the color in this painting. The illusion of sunlight was obtained with a bold pattern of warm and cool color. The large cast shadow in the foreground is a cool tone taking up about half of the picture space. Directly above it, there's a sunlit area light in value and quite warm in color. If you'll remember to keep shadows cool in color and lights warm, and to maintain this juxtaposition or contrast of warm and cool throughout the picture, you'll have sunlight. Now for the composition. Notice how the dark bank coming in from the right leads the eye to the girl's head. The group of treetrunks on the left acts as a stop. By making the model's hair the picture's single darkest dark, she becomes the focal point or the point of interest. The young lady is Gail, daughter of an artist friend, Donald Hewitt.

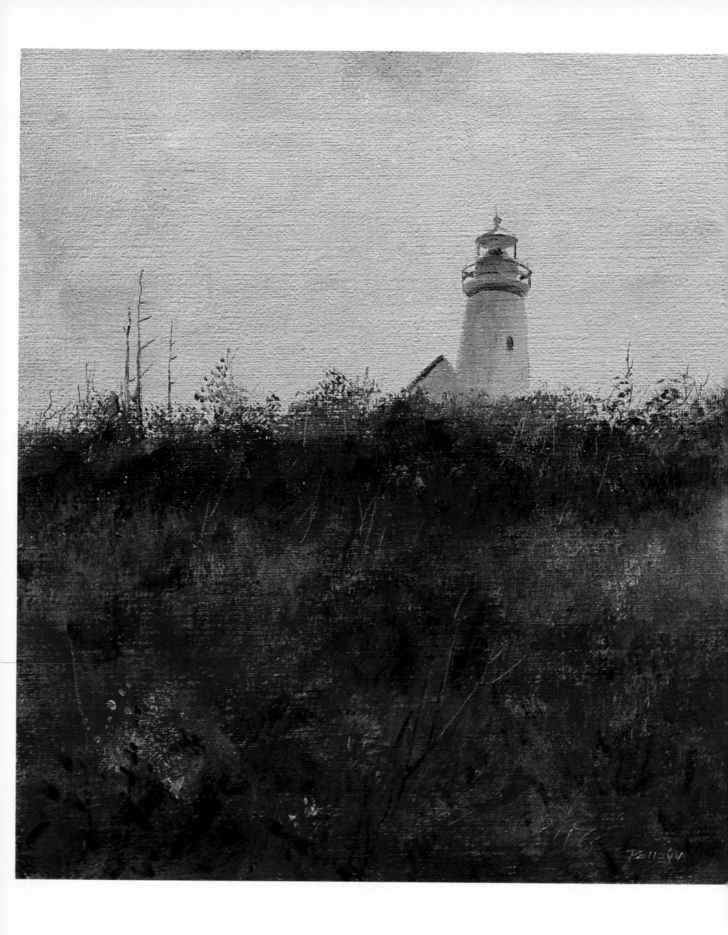

80

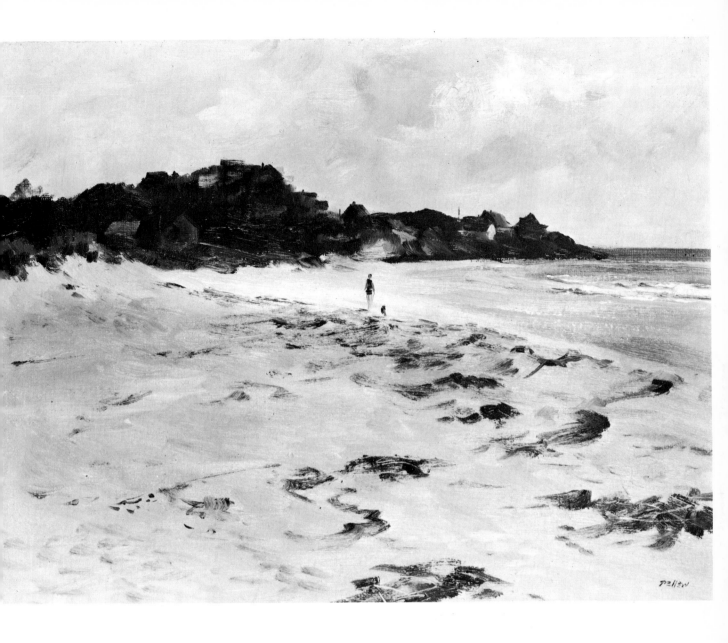

(Left) Fog Coming In, oil on canvas, 9″ x 10″.

This place doesn't really exist. Let me explain. I've sketched quite a few lighthouses in my time and have never been too happy with any of them. Looking over my sketches in the studio one morning, I came to the conclusion that in all of them I had taken too obvious a point of view. I was tired of those lighthouses perched on rocks or headlands with the waves dashing around their base. There must be another way to view a lighthouse. I had been telling students for years that nature seldom presents us with a ready-made composition. I finally took my own advice and created my own composition—a lighthouse picture with no ocean, no rocks, and no dashing waves. Somewhere, there must be a place where a lighthouse can be seen across such a stretch of open field. I've tried to suggest the presence of the ocean which is just out of sight. I've often seen such a sea fog creeping in, as Carl Sandburg put it, "on little cat feet."

(Above) Good Harbor Beach, Number 2, oil on gesso panel, 12″ x 16″.

This painting is reproduced here simply as a comparison to Good Harbor Beach on page 65. It was painted from almost the same point of view, but on quite a different kind of day—a fairly clear one with cloud shadows chasing each other across the beach. For the other painting the day was hazy and the air full of moisture. The kind of light and atmosphere present and the time of day do make a difference. The same subject can be painted more than once. Remember Monet's haystacks?

81

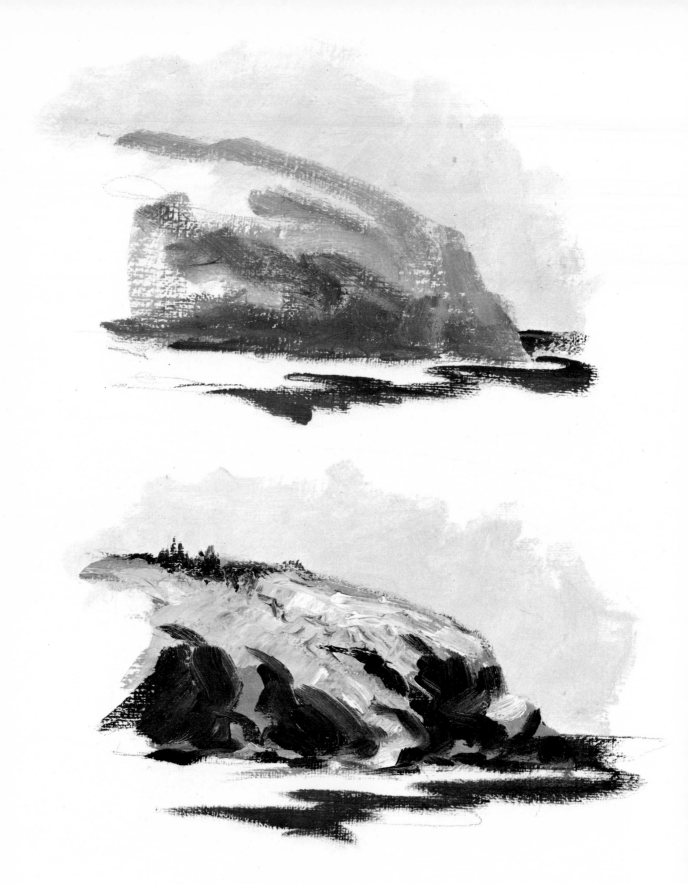

Figure 23 *The first sketch (top) for this rugged headland is the lay-in. The second (bottom) shows the headland boldly painted. Here the basic values of a landscape are seen. The sky, being the source of light, is the lightest value. The top surface of the headland facing up to the sky is the middle value. Because its steep sides are mostly vertical, they receive little light from the sky and become the darkest values.*

(continued from page 64)

I think a hazy morning in the fall is the best time to paint a marsh picture. A bright, clear day in October is delightful to be out in, but not quite so good for painting. But that's a matter of opinion. Some like bright light. I prefer it diffused when I'm doing marshes or a beach.

Lighthouses and headlands

A lighthouse is a great subject. If you don't know Edward Hopper's great picture *The Lighthouse at Two Lights*, look it up. It's worth seeing. Design your subject carefully. Try to avoid doing the usual headland with the lighthouse sitting up on top and a beach curving gently around some blue ocean below, complete with white-capped waves.

I painted *Fog Coming In* (page 80) without benefit of headland, beach, or water. I once did an old lighthouse in Huntington, Long Island, by just showing the top half against the sky. It's reproduced in my book *Painting in Watercolor*. Andrew Wyeth has painted parts of lighthouses: a window from one, a fog warning bell from another.

If you paint a headland—and why not—use the direction of your brushstroke to describe its character (Figure 23). Use horizontal strokes along its top with vertical (or near vertical) strokes for the sides, and maybe a mixture of both for the fallen rocks at its base.

Some of the best American headland pictures have been painted on Maine's Monhegan Island. Rockwell Kent, Robert Henri, George Bellows, Paul Dougherty, and Andrew Winter all produced fine pictures there. Now the younger men are discovering it all over again: James Wyeth, Don Stone, Tom Nicholas, and Paul Strisik are just a few.

I hope I've made you aware of the fact that marine painting can be much more—a whole host of marine objects, boats included (Figure 24)—than that everlasting wave pounding that blessed rock.

Figure 24 *Beginners often experience great difficulty in drawing boats. A good practice is to first sketch the basic form, getting it as correct as possible before developing the drawing. In fact, it's good procedure when drawing any object.*

ABOVE GREENBARROW, oil on canvas panel, 9" x 12".

At first glance this might appear to be western desert scene. It isn't. The broad Atlantic lies just beyond this painting's horizon. I painted it on the moors between St. Ives and Land's End in Cornwall, England. The moors have always held a great appeal for me. I've wondered why they've been painted so seldom by the artists who visit Cornwall each year. Perhaps it's because they've seen enough moorland in their northern English counties, or maybe they feel that the subject won't interest the picture buyer. This could be the reason. People that buy conservative, realistic art want their money's worth in subject matter. In our southwestern United States, cowboys and horses are popular. In the East, it's covered bridges and barns. So, in England I guess it must be thatched cottages and old ruins—what a pity. I think the moorland is beautiful. It's a quiet beauty, not obvious like the subjects mentioned. When painting there, I've often had miles of country to myself, not seeing a soul from start to finish. The scent of the heather and bracken, the hum of a bee, and perhaps the sight of a red cliff fox among the rocks—to me this is an ancient, beautiful land. It's the land of Arthur, of Tristan and Iseult, and it's well worth painting. To hell with thatched cottages!

Painting in open country

FOR MANY YEARS I lived in a big city, and getting out into the country meant a journey of several miles by car or train. Yet I did it from spring to late fall at least once a week.

The open country—what magic there is for the artist in those three words. When you view the open country, you experience the same excitement that's been enjoyed by artists throughout the ages—since the first painters felt the urge to capture on canvas the movement of the clouds on a summer day, the trees bending to the breeze, or the sparkle of sunlight on the tumbling water of a mountain stream. Now, I have the country just outside my door. Every day I thank the Lord for the privilege of living in this beautiful place and for being able to set down in paint what I see around me.

Observing nature

The first thing the beginning student has to learn is to *see* nature. The casual look won't do. You have to really *observe* and think.

You feel you know nature because some things are so familiar; you take them for granted, for instance, trees. Most of us see them every day; yet the beginner in landscape gives them so little thought that he ends up by painting all trees alike—often as green sponges on a stick. I love to paint trees, all kinds of trees at all seasons of the year. No two trees are alike and they're all beautiful. The painter should become familiar with the different types and spend time sketching them. A few sketchbooks filled with pen or pencil drawings of all kinds of trees will be time well spent. There are several good illustrated books on trees—like Henry Pitz's *Drawing Trees*—that are fun to look through on cold winter evenings when it's no longer possible to sketch outdoors.

The desire to paint

How do you paint an open country landscape? If I set down rules for how to do this or that, then painting becomes a formula and that leads to hack work. If you want an instructor to hold your brush hand, if you have no more self-confidence than that, then stick with number painting. The great American teachers, Robert Henri, Charles Hawthorne, and Harvey Dunn, never taught "how to do it." They taught the basic fundamentals: drawing, values, and composition. Their greatest contribution to art instruction was that they could inspire their students with the desire to paint.

In my youth, I attended a lecture by Henri given to a large group of students from the Art Students League. Although forty years have since gone by, I can still recall that tall, magnetic man as he stood before us, speaking quietly, but at the same time with such conviction that I'm sure every member of his audience went home that night determined to paint a good picture the next day. Henri was a great teacher, possibly the greatest this country ever had. Every art student should read his book, *The Art Spirit*.

No rules, no formulas

When you go to the country to paint, forget any preconceived "how to do it" formulas you may have floating around in your mind. Think instead of how beautiful nature is and how lucky you are to be there. You must have a love affair with nature if you're going to be worth your salt as a landscape painter. A brook flowing between rocks and grassy banks must be more to you than a series of brushstrokes placed this way and that way. It has to be a living, moving, beautiful thing, an effect of sunlight and shadow—a poem to be set down in paint. You've got to *feel* as well as *see*.

Oh sure, I can hold your hand and say do this and then do that. You probably would derive some benefit from advice so given. However, I would much rather have my words inspire you to go out to the country with an overwhelming desire to capture a slice of nature in your own way, because you're really alive and excited about what you're doing.

Light and shade in landscapes

The most important thing in a landscape painting—open country or closeup —is the light. Light and shadow create form. Even when painting a gray day, when definite light and dark contrasts aren't present, the painter must create an illusion of light throughout his canvas. If he fails to do this, the picture is a poor, dead thing.

One way to suggest light in a picture is to keep the shadows luminous. The tendency with amateurs is to make them too dark. Outdoors, the shadow areas are never really dark. They receive a great deal of reflected light, either from the sky or from other parts of the terrain lighted by the sun. Take a good look when next you walk outdoors and notice how high in tonal value the landscape is. Give it a serious look and I'm sure you'll be surprised.

This will be most apparent in open country. I think of this type of landscape as a light picture with dark spots. Be careful not to make the land areas as light in value as the sky, which after all is the source of light. There could be some areas lighter than the sky, but they would be reflected from a bright surface such as windows, a tin roof, or the sun reflecting off the water. I've seen beginners paint a distant, sunlit hill lighter in value than the clear sky behind it. This wouldn't really happen unless there was a thunderstorm approaching.

Because we're considering the business of creating the effect of light in a landscape, I feel I must stress once again the importance of correct tonal values. It seems to be the phase of painting least understood by the beginner. Start thinking of landscape values in the simplest terms. The sky is the lightest value, the ground facing up to the sky the next lightest, and the verticals (such as a tree against the sky or a building) the darkest. These are the main values in any landscape. Train your eye to see this big pattern before you think of the in-between values. If you squint at your subject with half-closed eyes, you'll begin to see the important values in their correct relationship.

SUNLIGHT AND SHADOW, oil on canvas, 20″ x 28″.

A pair of pet ducks once lived in the little shack shown behind the tree in this picture. They belonged to my neighbor's children. One night a raccoon or some other wild animal killed one of the ducks, and soon after the survivor flew away with a mallard that came by and gave her the eye. The two ducks were once in my picture, but after they'd gone it upset the children to see them, so I painted them out. I never tire of the sunlight and shadow patterns I see so often between the house next door and my own. In this picture the fore-ground, except for a few sun splashes, is in shadow. Beyond the ducks' old home, the neighbor's back lawn is in full sun. I noticed this effect one morning and was determined to be ready for it the next day if the light was right; it was. I chose my point of view carefully in order to have the branches of the pine tree contrast strongly with the sunlit area beyond. It was necessary to work as rapidly as possible, because I knew the light effect wouldn't last. Painted with brushes throughout, there's no knife work in this painting.

Water and reflections

The painting of water in a landscape often gives the beginner some trouble because his approach is wrong. He feels that because water isn't solid, like the land, it requires some special treatment—some kind of trick to make it look wet. This isn't true, of course; just think of that puddle, pond, or brook as color and value. Get these two right and it will be water. After all, what's the painting of anything but putting down color and tonal values?

Another question often asked about water is, "How about reflections?" When the amateur artist finds a placid pond reflecting some beautiful trees, it's ten to one he'll divide his canvas through the center, making the trees and their reflections equal in size and importance. Generally speaking, the picture space should never be divided in this manner. I won't say a successful composition can't be made with the top and bottom halves equal, but it's not a good way to do a picture of reflections. You always feel you want to turn the canvas upside down to see which half looks best. If the reflections mainly attracted you, then give them most of the space. Keep in mind that almost all landscape subjects compose best with the eye level or horizon well *above* or well *below* the center of the space.

What about color? In calm water, reflections are mostly the color of what's being reflected—with the water acting as a mirror. Don't paint a blue reflection for a yellow tree on the bank. I've seen it done. If the water of the pond is rippled by a breeze, the reflection will have a greater variety of color, because the little wavelets will sometimes reflect color from the sky while the water between them will reflect what's above on the bank. It's all a matter of observation and really thinking about what you observe.

Painting gentle, rolling country

Students that have no difficulty painting hills that look like hills run into trouble when they attempt gentle, rolling country. Their rolling country has a tendency to flatten out. This is mostly due to the contrast between light and shade; it's not as definite or apparent as it is among the higher hills. It's there, but more subtle, and it's the subtleties of the tonal values that create the rise and fall of the low, gently rolling hills.

There's also the matter of aerial perspective. As the hills recede from foreground to distance, they will probably become grayer and cooler in color and lighter in value. The same kind of trouble arises, at times, when you attempt to paint a large flat field or meadow. It just refuses to "go back," or recede. My advice here is to keep the foreground simple with broad brushwork, and suggest detail in the middle distance. Then, use small brushwork and again cooler color with lighter values in the distant parts of the big field. This is only a suggestion, a general rule. Under some lighting conditions it wouldn't work at all.

Painting mountains

Up to now I've been dealing with more or less flat and rolling hill country. Now let's go to the mountains; everyone does sooner or later. What's so difficult about painting mountains? Nothing really. However, just as the inland dweller meets a great many problems when he tackles a marine painting, so does the amateur when he first attempts to paint mountains.

Composition, as a rule, isn't given enough thought. The amateur allows nature to dominate his thinking and paints the obvious—one big mountain smack in the center of the space. The result, if well enough painted, looks like a postcard.

TIDAL CREEK, oil on gesso panel, 10″ x 14″.

These tidal creeks flowing through the salt marshes of parts of our eastern coastline have a great appeal for me. I like to paint them in spring and autumn. It's then that the coarse grass is most colorful. In early spring, when this picture was painted, the land areas were covered with the remains of last year's grass. In color it was all shades of ochre—from a deep tone that was almost pure raw sienna to a pale, warm white. On this particular day the tonal value relationship between land, sky, and water was rather strange. The dead grass covering the marshy land lay shimmering in the
sun and was actually lighter in value than the hazy blue sky. The calm water, except that which was close to the banks, reflected the sky's color and this, too, was darker than most of the grass covered marsh. This was the reverse of the values seen in the usual landscape subject—a tricky thing to pull off. The value relationships had to be right in order to successfully capture the mood of the day. These marshes seldom make "pretty" pictures but they sure make the landscape painter think. I enjoy the challenge.

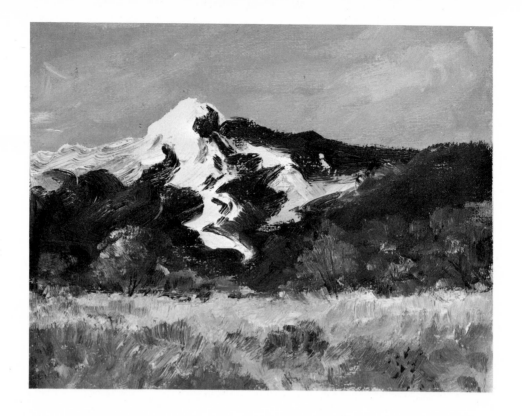

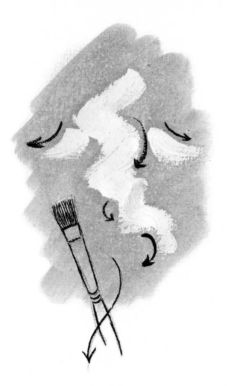

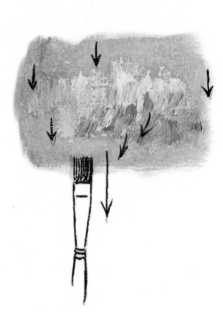

Figure 25 *Paint application—the actual brushstrokes—can be of utmost importance in a rapid outdoor sketch, especially in such areas as the snow on the mountain in this demonstration. Bold brushwork is used on the snow to describe the form of the mountain. The paint is thickly laid on with a flat, bristle brush. In the diagram (bottom left), I indicate the direction of these strokes. The texture of the foreground grass is created with short overlapping vertical strokes, using the same brush with a downward movement (bottom right).*

When composing a mountain picture, remember the rule about more sky than land or more land than sky. Decide right away which you'll use. Never—but never—have sky and land areas equal when doing mountains. Next, keep that mountain peak away from the picture's center. Place it to the left or right of center and look around for something to balance it on the other side—it can be something small. Balancing a large mass with a small one is an old device often used by landscape painters.

If the mountain itself is to be the composition's focal point, design the space in such a way that it leads the eye to the point of interest (Figure 25). Don't be too obvious about how you do this. Gently curving lines are better than long, straight ones which rush the eye of the viewer into the picture too rapidly. While on the subject of lines, don't run them into the lower corners of your composition. The amateur often does this with stream banks or the edge of a road. Such lines only rush the eye right *out* of the picture.

Two methods of composing mountains

I think there are two ways to treat mountain subjects successfully (Figure 26). One way is to use a low horizon and a big sky. The mountains in this approach will be fairly distant. There's a chance here for lovely, cool color in the mountains, contrasting with the warm color of the foreground at the painter's feet. This foreground should be very simply stated with little or no detail. Remember that you can't look up and down at the same time. Paint the foreground as you see it when you're looking at the middle distance.

The other way is the closeup—for example, the stream tumbling over rocks on its way to the valley floor, or perhaps a jumble of rocks in a ravine. Often, this type of mountain subject can be painted without any sky. Chances are the sky can't be seen anyway. The closeup requires good abstract design, rugged forms, and rich textural effects.

Matching your equipment to the terrain

If I go into the mountains to paint, I keep my equipment as simple as possible. For working with oils, I carry a 9″ x 12″ wooden sketchbox with a slotted lid which holds three panels. Everything goes into the box to which I've attached a shoulder strap. This is a great help when both hands are needed to climb a rock or get over a fallen tree. An easel would be in the way so I do without one, putting the paintbox on the ground and using the lid as an easel. No, mountains aren't any more difficult than anything else to paint. They're just more difficult to get to, that's all.

Color and the seasons

One of the things I like about living in New England is that each season is quite different from the one preceding it. This keeps the landscape painter on his toes. At times, I've been asked by students about what colors should be carried in the paintbox at different times of the year. Well, that's easy for me to answer. I've got the same set of colors in my box all year 'round. I've listed them in Chapter Two. Ten colors with white should be enough for anyone. The color manufacturers don't think so, but I do.

Instead of thinking that you have to buy colors to match the changing seasons, try mixing the colors you have to suggest the color of the season you're painting.

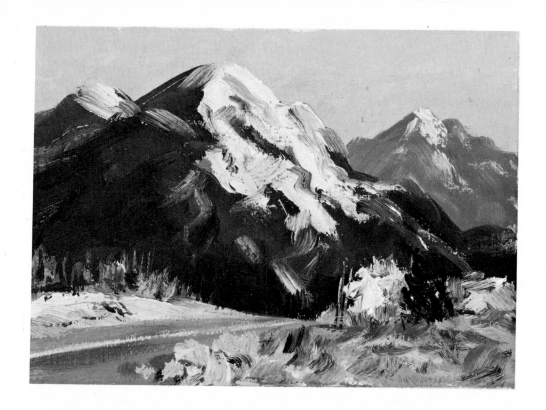

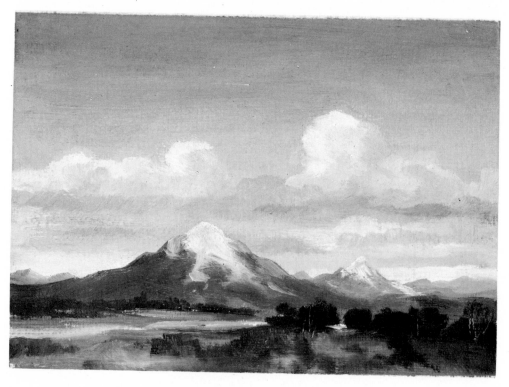

Figure 26 *Here are two approaches to mountain painting. The top sketch shows thickly applied paint with the strokes following the form of the mountain. In this type of painting there's no attempt to disguise the work of the painter. In fact, the surface quality could be called "painterly." In the second sketch you see the classic approach of the Hudson River school, which flourished in the nineteenth century. In paintings of this kind, great skill was exercised to keep the hand-writing of the artist from being seen. The surface quality is smooth—the effect serene.*

Figure 27 *When painting the bare trees of winter, the amateur artist often forgets the twig mass. He carefully draws the trunk and the branches but seldom puts in the gray tone formed by many thousands of overlapping twigs. I often suggest this tone right at the start—painting it over the sky as shown on the left side of this sketch. The more fully developed trees are shown on the right.*

WINTER AFTERNOON, oil on canvas panel, 12" x 16".

Driving down the Merritt Parkway in Connecticut late one December afternoon, I passed a succession of scenes like the one pictured here. As I was the passenger, not the driver, I had plenty of time to study the passing landscape and store up my impressions. The most interesting I found was how dark, almost black, the trees were in contrast with the snow covered ground. The sun, being low, gave a pale orange glow to the sky which in turn cast a pink glow on the snow in the foreground. Back toward the trees the snow became cool in color. The patches of marsh grass poking up through the snow were colorful notes. Some were pure yellow ochre; others were dark and rich in color. For these I used mixtures of raw sienna and burnt sienna. By the time I reached home I had the picture fixed in my mind. The next morning I painted it. I'm glad I had sense enough to keep it small. To create a broadly painted impression such as this on a large canvas would have been difficult. The paint was thickly applied using brushes for the trees and grass. The snow was painted for the most part with a palette knife.

In the spring, there'll be tender greens and yellows. At this time of year, the bare twig masses have a definite violet cast, while those beginning to bear buds have a blush of red. Grays, both warm and cool, are always present.

In summer there's an abundance of green, a color that drives some painters around the bend and others to the seashore. Don't be afraid of the rich greens of summer—John Constable certainly wasn't. Here's a tip. Instead of purchasing prepared greens in tubes, experiment with color mixing as I've mentioned. I'm a great champion of raw sienna. Mixed with thalo blue, it produces a variety of greens. Cerulean blue with yellow ochre is also good. There are all kinds of combinations of the various yellows and blues that can be mixed to obtain greens. Even burnt sienna and blue will make green. The greens you mix yourself are, in my opinion, more interesting than the prepared tube colors.

Each year, the New England autumn foliage sets amateur painters (and some professionals) to painting a great many garish pictures, splashed from border to border with intense reds and yellows. They forget that when all the colors are bright, there's no brilliance. I think the fall foliage looks best on gray days. The leaves are colorful enough; they don't need the sun to make them more brilliant. I confess that I do add alizarin crimson to my palette at this time of year.

Winter is the season of grays—all kinds of grays, both warm and cool. Tree-trunks are gray, never brown—well, hardly ever (Figure 27). The beeches are silver gray, the birch almost white, and the oaks dark gray—even black when wet. Last autumn's fallen, faded leaves are all kinds of warm grays. Yes, gray is the dominant color in winter, but don't forget that there's a lot of gray in nature during all seasons.

OCTOBER AFTERNOON, oil on gesso panel, 16" x 20".

The clear, bright light of an October afternoon is beautiful but often difficult to paint. The hazy atmosphere of early morning which separates values and makes it easy to give the picture depth is missing. The illusion of recession must be obtained by design alone. In this case the receding sand bars and the distant house made the problem less difficult than usual. The low light of late afternoon spotlighted the side of the house. This I found quite attractive in contrast to the dark trees behind the house. I knew this effect would be gone in a very short time, so I quickly painted the house and the dark value of the trees around it before going on with the rest of the picture. The sunlit part of the house and its reflection in the salt water pool are the picture's lightest lights. Everything else has been kept lower in value to enhance the sparkle of these lights. Although the foreground sand bank has been simply treated, notice how it has been made interesting by bold brushwork that suggest footprints, etc.

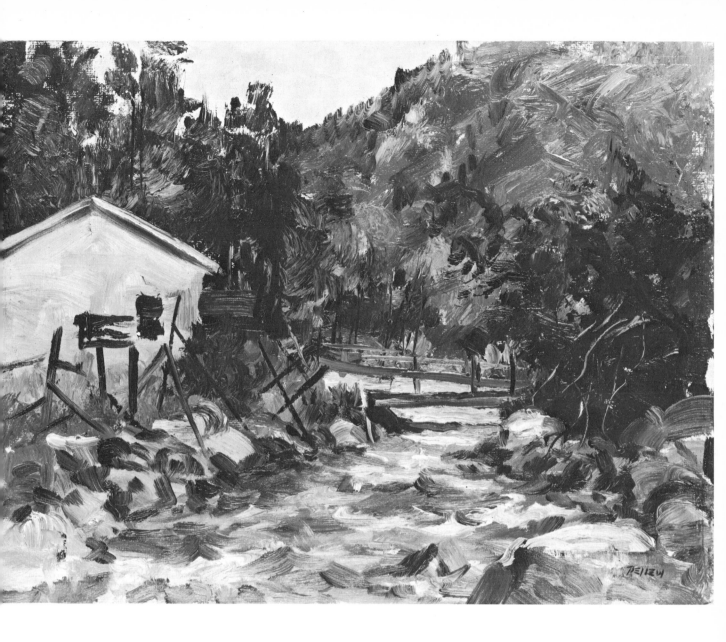

COLORADO COUNTRY, oil on gesso panel, 12″ x 16″.

This is a demonstration sketch painted for a landscape class at Georgetown, Colorado. A painter can hardly be at his best with thirty onlookers watching every brushstroke and also asking questions. However, in spite of the handicap I don't think this one came off too badly. It was rapidly painted with well loaded brushes. There was no palette knife work at all. Everything except the sky was thickly painted. Detail was suggested rather than defined. This was done with a kind of landscape painter's shorthand or calligraphy, if you prefer the *more elegant term. It's easily seen in the mountainside where much was suggested with a few squiggles and dashes. The rocks left and right were also quite simply treated, their form indicated with strong top lights and strokes of darker value for the sides. The turbulent stream seemed to give my students the most trouble when they tried to paint it, because they overworked it, trying for too much detail. I simplified it greatly but retained its character. Suggest the character and get the values right and you won't need details.*

THE DREAM, oil on gesso panel, 30″ x 40″.

Although most of the paintings reproduced in this book were made on the spot, I think some studio work needs to be shown. My studio paintings all grow out of things done in the field. Even those I call improvisations become new paintings from impressions of landscape seen and recalled. There was plenty of landscape material to work from—in sketches around the studio and stored in my memory. I painted the figure from a photograph of a professional model. I've painted the fields near my home at all seasons. A couple of 9″ x 12″ sketches

made in the early fall were the inspiration at the start but I forgot about them as I worked. First I painted the warm, light sky; then with a large brush, I scrubbed in the dark foliage tones. Next, a warm middle tone was painted over the entire foreground. This was my lay-in. From there on it was a matter of developing textures to represent the various types of growth—weeds, etc. After putting in the dark treetrunks, I had a pretty fair landscape but felt that the composition lacked something. I found it, as you can see.

Working from drawings, photographs, and memory

SOMEONE—I THINK it was Degas—said, "Show me a man's drawings and I will tell you what he knows." I go along with that. Good painting that pretends to represent nature, whether it's highly finished or a mere impression, can't exist without good drawing. A landscape painter draws with his brush with every stroke he puts on canvas. Paint thick; paint thin. Use the palette knife or brushes or both. But technique won't save you if you're a weak draughtsman. I can possibly forgive a great colorist—they're so rare—but there's no forgiveness for the average painter who's a poor draughtsman.

The craft of drawing

You learn to draw by drawing. Draw anything, but draw. It's difficult to convince the amateur landscape painter how important this is. Recently, I told a student to get into the habit of making a quick drawing of something every day. She said she wasn't interested in drawing, only in painting. I hate to think what any of my old instructors would have replied to that!

Composition, drawing, values—these are the important parts of picture making. Omit any one of the three and you have no picture. Drawing is line, position, and proportion. *Line* can be a graceful curve, a bend in the road, or the sweep of a willow branch. It can also be the outline of a rugged mountain range against the sky. *Position* is where you place the trees or mountains, and *proportion* is the size you decide to make them within the four borders of your space. Good drawing is based on good observation. It's actually true that most people don't really *see* what they look at. You must not only look, but you must *think* about what you are observing in terms of tonal values, composition, color, division of space, and abstract pattern.

Good drawing, like good painting, is never merely a copy of nature. Your drawing should be as personal as your handwriting. Just think about how different the drawings of Rembrandt and Ingres are—yet both were great draughtsmen. There's a fine *Winter Landscape* by the former in the Fogg Art Museum, Harvard University. It's just a few lines on a scrap of paper, measuring $2\frac{5}{8}''$ x $6\frac{5}{16}''$, but how telling those few lines are! The essential truth has been expressed powerfully, and that's more important than the tight, finicky rendering of unimportant details.

I've been told that drawing is out of fashion today. Out of fashion with whom? Not with the serious student of art; certainly not with the landscape painter who wishes to create an impression of the visible world.

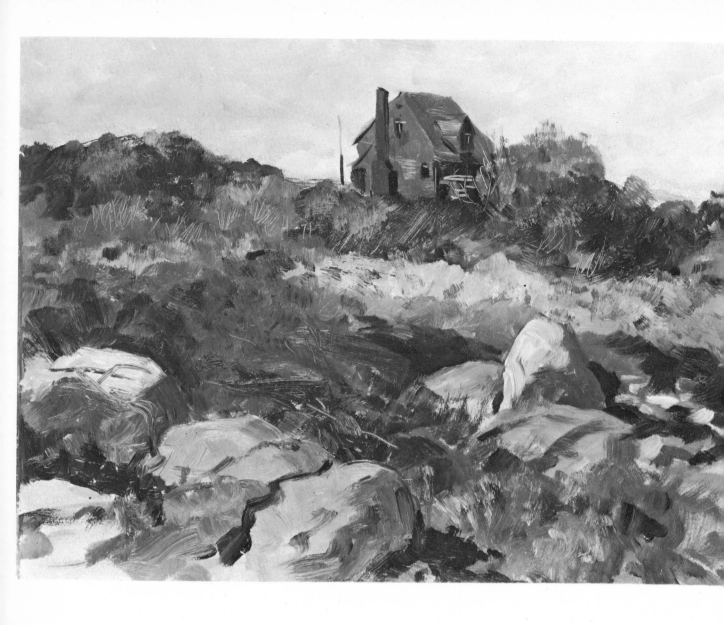

SPRING ON CAPE ANN, oil on gesso panel, 12" x 16".

I found this house, situated above the beach and surrounded by a variety of spring greens, quite intriguing. On Cape Ann the month of May can be very beautiful and the day I painted this sketch was no exception. The house seen against the sky was quite cool in color, making a nice contrast with the warm green of the weeds, grass, and bushes. The rocks also contributed to the warm and cool contrast. Their sunlit tops were warm, almost pink, and their shadowed sides quite cool. There's also some pink in a patch of twiggy, dead bushes in the upper left. Many students and beginners find green difficult, because they fail to experiment enough with color mixing, and depend too much on the prepared tube green. I've no green in my paintbox. I mix various greens from combinations of yellows and blues as I've mentioned in Chapter Three. I've used thalo green in the studio. Someday I may add it to my paintbox colors for outdoor work. It seems to be the most useful of the prepared greens.

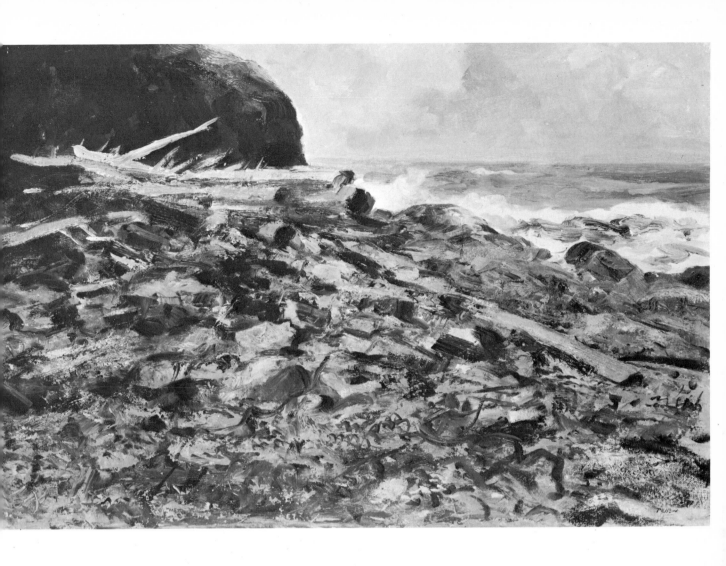

PASSING STORM, oil on Masonite, 20″ x 30″.

Degas said, "A work of art is first a product of the imagination." My picture is almost that—but not quite. A few years ago I visited Mahogany Island in the Bay of Fundy, Canada. It was a one-day visit on a calm summer day. I took with me a lightweight drawing board, some sheets of paper, a bottle of drawing ink, and some brushes. I made several drawings that day, some along the beach and others in the scrubby pine woods. This painting and some others grew out of these drawings. To transpose a drawing into oil paint, and in color at that, you'd better have some imagination. A good visual memory also comes in handy. The first I think you're born with; the second can be acquired through practice and experience. It was fun turning the calm day into a stormy one. Except for some green at the top of the cliff, the picture is very gray. However, the grays are colorful. Throughout the rock-strewn shore, there are blue-grays, pink-grays and a great variety of brown- and yellow-grays. I don't believe in mixing plain black and white to obtain a gray. This picture is a good example of what can be done from a drawing if the painter can observe nature.

The quick sketch

It's a good idea to go sketching with a sketchbook and pencil or pen. You can get a lot done in a morning. Years ago, when I had to work at a job in New York City, I carried a small sketchbook in my pocket. I often used it in Central Park on my lunch hours. I sketched the people, trees, park benches, and even animals in the zoo. I also sketched in the subway and in the Metropolitan Museum of Art. Material gathered on the pages of those little books was sometimes the inspiration for paintings in either oil or watercolor.

Finding a suitable drawing medium

Experiment to find your favorite drawing medium. When you find it, stick with it. Work with that one medium until you don't have to think of what you're working with—only what you're trying to say. There are any number of things you can use to make marks on paper. There are all kinds of pens: the ballpoint makes a fine line; the felt pen makes a fat line; a Pentel pen makes a line somewhere between the two.

A stick dipped in ink is an interesting drawing tool (Figure 28); it was good enough for Rembrandt. The trouble here is that you have to take a bottle of ink along. Some great landscape drawings have been done in a combination of pen and wash. If you feel that you must have some tone in your drawings, this is a good medium to use—I like it.

My favorite method is to dilute the drawing ink with some water so that it's dark, but not jet black. I use a small, pointed sable watercolor brush to draw with, then put in some tones with burnt umber watercolor. In order to do this, I must carry a couple of brushes and the smallest watercolor box available. Oh yes, there also must be a small bottle of water along. If you think this begins to get complicated, there's always the old reliable pencil. For a fine, sharp line, use a 2H. For thicker lines, use softer grades, HB or 2B. For tones and rich darks, use 4B and 6B.

Drawing on the spot

Painting landscapes from drawings made in the field is an interesting and often rewarding experience. When you work from a drawing, you're not confused by the bewildering display of detail always present outdoors. In making the drawing, you put down only what's essential and you'll probably work rapidly, giving the drawing a spontaneous character which should carry over to your painting.

I don't think large paintings should be made from small drawings, but I've often made 16″ x 20″ and 20″ x 24″ oils from my sketchbook drawings. Small drawings just don't contain enough reference materials to carry over into the making of a large painting. To paint from a drawing, the sketch should be no smaller than 10″ x 14″. As you sketch, write notes on the drawing about color or anything else you want to recall when back in the studio. It's a working drawing, not a work of art in itself.

Painting from a drawing forces you to make up for the lack of detail by concentrating on the big value pattern and on paint, or surface, quality—two things often neglected in the rush to set down that quick impression when painting outdoors. *Surface quality* is the manner in which the paint is laid on the canvas. When you say a painting has good surface or paint quality, you mean the paint has been applied in an interesting or, perhaps, beautiful way. A good surface has unity, while a bad one might be lumpy, full of pits, and dried-in spots.

Figure 28 *This drawing from nature was done using a sharpened stick and ivory black watercolor. It's impossible to get tight or concerned with detail when you use a tool of this kind. It's also lots of fun.*

AN IRISH LANDSCAPE, oil on paper, 9″ x 12″.

This and the picture I've called Ring of Kerry *are the kind of landscapes I like to paint in that most paintable of countries. Both Ireland and England have so much beauty to offer the landscape painter; I think it's too bad that amateur American artists when they visit those countries paint (in my opinion) the wrong things. They always want to paint the obvious; professionals—good ones—never do. The first sight of a whitewashed, thatched cottage or a ruined castle and the amateur can't get his paints out fast enough. Behind the artist there may be a landscape so Irish it brings tears to the eyes —the rich black and brown of a cut peat bog, or bright sunlit fields in all shades of green, and in* *the distance, cobalt blue mountains. But there's no cute cottage in any of these subjects and the amateur landscapist must take home a thatched roof picture. "What's wrong with it?" they ask. Well, certain subjects have been painted so often since Victorian days that they've become boring. You don't have to paint a thatched cottage to prove you've been in Ireland or a windmill to tell us you've been to Holland. Soon I expect to take a group on a New England Painting Holiday. I certainly hope none of them will want to paint the old fish house at Rockport, Massachusetts, known as "Motif Number One," though I bet they will.*

Painting from photographs

What about working from photographs? I'm not against it, if it's intelligently done. There are a great many painters working from photographs today—but you won't get many of them to admit it. Remember that making a skillful copy of a photograph proves only that you're a skillful copyist—not an artist. A painting is a very personal, handmade thing; a photograph is machine made. A painter can think, have ideas; a camera is a mechanical eye. In the hands of a professional, the camera can produce some beautiful pictures. But you can't hire the world's great photographers, so you take your own.

Today, even the cheapest camera takes pretty good black and white photos and color slides. However, don't fool yourself that they're true to nature—they're not. The tonal values in a photo are hardly ever in their correct relationships. This is because when you set your exposure to register the detail in the lights, the shadows are underexposed. If you shoot for the shadows, the lights go haywire. On sunny days, color film gives you a blue sky that's much too intense, and shadows that are, in some cases, almost black. Because of these things, it's fairly easy to spot a painting that's been made from a color slide by a skillful copyist. They turn up in lots of exhibitions.

When I work from a photograph, I prefer to use a black and white print. It's too easy to get trapped into false colors and false values when viewing a color transparency. Often I'll make a drawing in ink and wash from the photograph. When the drawing is finished, I put the photograph away and paint from the drawing.

It's impossible to have your painting look photographic if this method is used. It's that photographic look that often creeps into a painting done directly from a photograph that's so deadly, you wonder why the artist bothered. Why "enlarge" a photograph by hand on canvas when the same (or even better) result could be obtained by the purchase of a good photo enlarger?

Of course, I don't mean that all detailed paintings are photographic. The American Tempera School artists paint in great detail, but only a few of them are photographic in their approach. The best of these artists displays a fine abstract quality of design that no amount of finicky detail can destroy. I think the water-colorists are the worst offenders, but that's another story outside the scope of this book.

The best advice for the amateur is that when working from a photograph, don't allow it to dominate your thinking, and when painting from nature remember that's a brush you have in your hand, not a camera.

Painting from memory

One good way to overcome tightness or the tendency to be too concerned with detail is to try painting from memory. It can be great fun and, after a few false starts, not as difficult as you suppose. Your success will depend on how experienced you are. If you have a couple of summers of outdoor work behind you, it should be a beneficial experiment.

For a first attempt, set up a simple still life with a drape or curtain between it and your easel. Study the still life for awhile; then go around the curtain and start to paint. When you get stuck, go back for another look. Proceed until finished, and try not to look too often. Robert Henri, the great teacher, recommended this practice to his life class students. He said that the beauty of painting from memory is that so much is forgotten.

Ready to try again? Okay, this time take a landscape you've recently com-

A ROCKY SHORE, oil on gesso panel, 10″ x 14″.

There's nothing much to say about this picture that I haven't already said concerning my other Bass Rocks paintings reproduced in this book. It's one of many painted in that area. There will be many more, I hope. I used a great deal of broken color in the rocks. There's some palette knife work on the rocks nearest the ocean. The small dark dot on the horizon suggests a lobsterman off shore and helps, I feel, to give the picture depth. The larger rocks found on that coast are a warm ochre color. The small pebbles, so well washed and rounded by the ocean, are all colors from a deep blue through various tones of brown, yellow and red, to almost pure white. The paint was thickly applied. The medium used was Grumbacher's Copal Painting Medium.

Surf Watcher, oil on watercolor paper, 16″ x 20″.

*I was tempted to call this "Elsie, On the Rocks,"
but since the lady is my wife I thought better of it.
Whenever we go to Cape Ann we visit Halibut
Point if there happens to be surf running. The big
waves crashing against the rocks make you realize
how powerful a force the ocean can be. This wasn't
a stormy day, although there was some surf along
the shore. I was really interested in seeing how
simply I could paint the rocks and still retain their
solidity. I believe I managed this fairly well. The
trick is not to paint every rock or every crack in
each rock; you must simplify. Except for the strong*
*top light in front of and behind the figure, the
rocks were almost painted in two values. Of course,
I saw more tones than this but to try matching
tone for tone would have been a mistake. The whole
big mass would have been broken up and unity lost.
A good picture has "oneness." In the great Winslow
Homer marines most people are so interested in the
painting of the ocean that they neglect some of the
greatest rock painting ever done. It's a fact, though,
that he once advised a young student, "Paint the
figure; rocks are easy."*

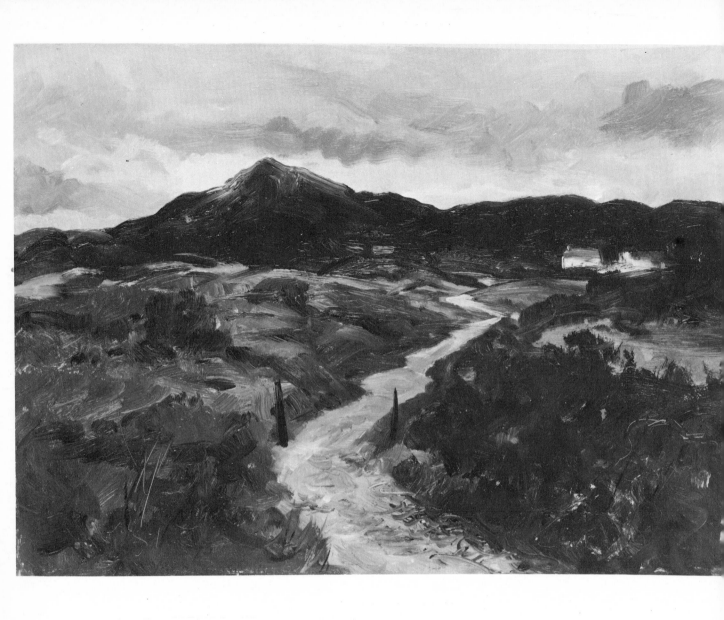

THE ROAD ACROSS THE BOG, oil on gesso panel,
10" x 14".

*Ireland isn't just all green. True, there's lots of
green but plenty of other color also. The mountain
in this picture, for instance, is a deep and beautiful
blue. This little road over the bog, with the cottages
at the foot of the mountain, was a joy to paint.
The sky was beginning to clear after a shower. If
you can be on the spot when that happens you're
a lucky landscape painter. I was there but not
equipped to paint, because I was driving with a
group of friends. So I did the next best thing; I
took a photograph. I've said elsewhere that the
camera can be a useful tool if used intelligently.
A great many excellent artists have made use of
photographs. This Irish landscape was painted in
my Connecticut studio when I returned home.*

pleted. Set it on the easel and study it carefully. Talk to yourself while you do this; your family may think you've "flipped," but no matter. Tell yourself pertinent things about the picture—where the horizon is in relation to the center of the space, what's the character of the sky, what kind of cloud formation exists, if any, and where the darkest darks and the lightest lights are located. Tell yourself some things about color and so on; in other words, "read" the picture. This will help you register the image. Now put the picture away and don't look at it again. Paint it from memory on a new canvas. You may be surprised to find that the memory painting is the better of the two. Degas said, "A painting is first a product of the imagination."

When you paint in the field you're actually painting from memory. You look at the scene before you; then you look at the canvas on the easel, and you paint from the mental image formed in your brain. You can't look at the landscape and at your canvas at the same time, so isn't that a kind of working from memory? I think so.

Whistler's night views of the Thames from Chelsea were memory paintings. He would go with a friend to the scene he wished to paint, turn his back to it, and have his friend "read" it to him. Sometimes he would study the subject carefully, then turn his back and tell his friend what he had seen. In this way, he stored the image in his mind. The next morning in the studio he would paint it.

These are just a few hints on how to train your memory. I hope you'll give them a try.

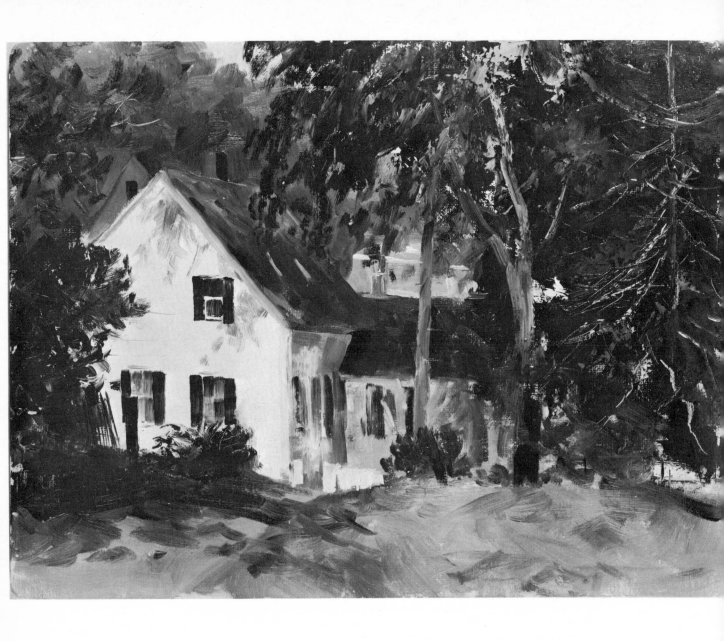

THE HOUSE ON SCHOOL STREET, oil on gesso panel,
12" x 16".

*Perhaps this should be called "Forever Rockport,"
because it's the most recent of a host of pictures
that I've painted in or near that town on Cape Ann.
I like the plain white house in contrast to the rich
tapestry of the September foliage. The trees hadn't
yet changed to their full autumn color, but they
no longer had the all-over green look of summer.
I painted the foliage with mixtures of raw sienna,
yellow ochre, burnt sienna, and thalo blue. For the
most part these were applied with the palette knife.
I warmed the white of the house by mixing a little*
*cadmium yellow light into it. Never paint the sunlit
side of a white house with just white paint; it's too
cold. The shadow tones on the house were mixtures
of cerulean blue, cadmium orange, and white. The
treetrunk and the pole to its left were painted over
the house and foliage. Some of the thin, light-
struck branches at the far right were scratched in
with the point of the knife. I painted the windows
into the wet white of the house with a brush that
was lell loaded with dark paint. This painting was
completed in three-quarters of an hour.*

Shop talk

''SHOULD I JOIN a class?'' My answer to that question is always, "Yes, if possible." It's not so much the instruction you get from the teacher, although that can be valuable if you're lucky enough to find a good one, it's the contact with the students that's inspiring.

Teachers and classes

If you have a choice, select your instructor with care. Some very good teachers aren't great painters, but they have the ability to impart knowledge to others. On the other hand, there are some good painters who don't have the gift of teaching at all. There are quite a few around who are most articulate—a polite way of saying windy. Watch out for this type. They talk a great picture and can hold forth for hours on theory, but with a brush in their hand, somehow they aren't as impressive.

If you find a teacher with a good exhibition record and the ability to paint a class demonstration, give him a chance. He may be able to open up new worlds for you. Follow his advice and don't panic if somewhere along the line your work begins to resemble your teacher's. It won't be as good, of course, but you may begin to use some of his mannerisms. You start thinking that you have no originality. Forget it. Originality, if you have any, will come into your work in time—you won't be able to stop it.

Visiting museums

Go to exhibitions of paintings and to a museum if there's one nearby. Imitating the work of a painter the student sincerely admires is no sin—we all do it when we're young. But to go on doing it is a mistake. Sad to say, even competent painters sometimes get trapped by their admiration for a contemporary who's enjoying a popular success.

Look at as many paintings as you can. Listen to your instructor, and read books on the subject. Then go to nature week after week, year after year, and slowly develop your own personal style. It's the only satisfactory way.

Attending demonstrations

Painting demonstrations have become quite popular in recent years. This wasn't so when I was a student. Demonstrations by well-known painters did take

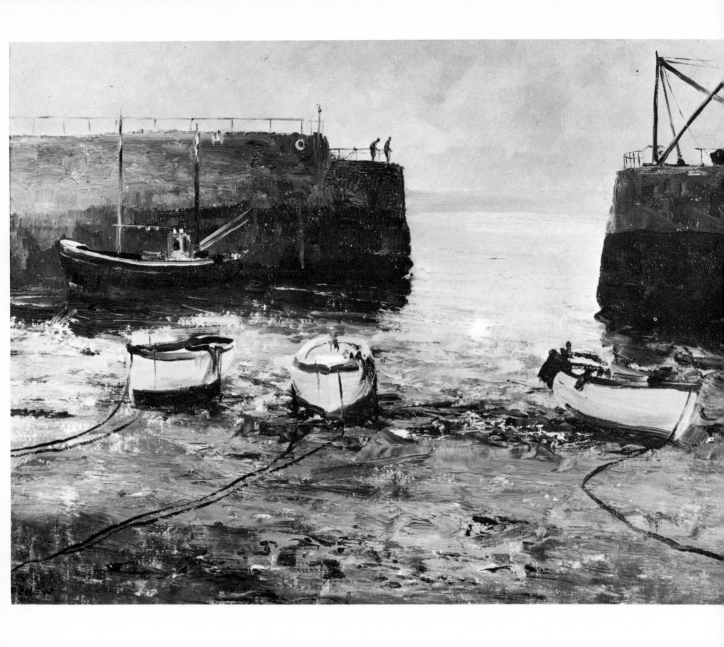

MOUSEHOLE, CORNWALL, oil on canvas panel, 12″ x 16″.

This picturesque harbor on the Cornish coast of England has been painted more often, perhaps, than Lanesville Cove on our own Cape Ann. In fact, the two places are very much alike with their massive stone piers. I first sketched Mousehole Harbor when I was a schoolboy living in nearby Penzance. The picture reproduced here was painted on a calm summer morning at low tide. It can be a quite different place in winter with a southwest gale blowing into the bay and sending huge waves over the harbor's stone piers. I'm sorry we don't have this picture in color. The richly pigmented foreground

with its wet mud has a lot of broken color. Picking up both warm and cool color with a large brush, I put it down on the panel without much mixing. In this way I obtained the colorful luminosity of the mud and the puddles left by the retreating tide. The mud is warm in color contrasting with the cool sky color reflecting in the puddles. The stone piers are a warm gray in their upper parts and dark green where the rock weed clings to their lower halves. I wish that fine American marine painter, the late Gordon Grant, could have seen this one. He was fond of Mousehole.

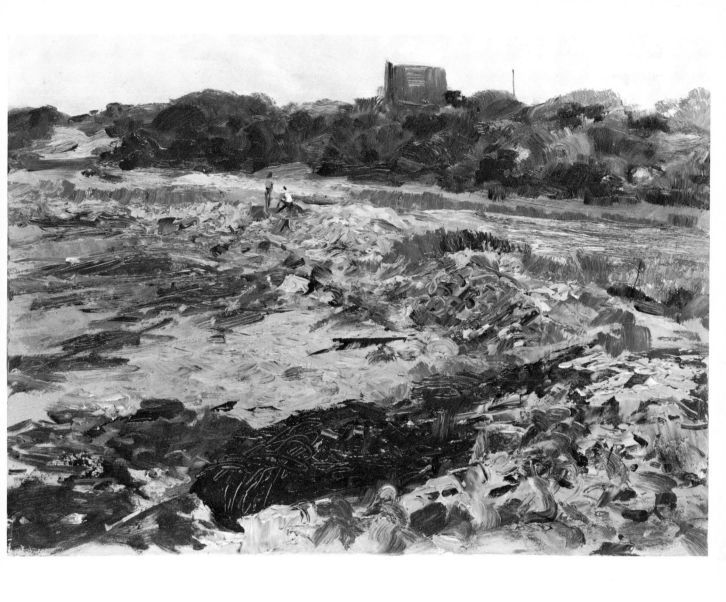

HIGH-WATER MARK, oil on gesso panel, 10″ x 14″.

The day was all sparkle. The light was bouncing off the pebbles and patches of sand, the little salt water pond above the beach was all aglitter. The trees and bushes in their new spring foliage were brilliant with many shades of yellow-greens. The bank, running from the right foreground up through the picture's center, was made up of pebbles, rocks, and beach debris left at high-water mark by the winter storms. The two small figures give you some idea of its size. In the middle foreground there were heaps of dark brown and green rockweed torn from the offshore rocks and thrown helter-skelter onto the beach. After winter storms beaches can be happy hunting grounds for painters. All kinds of interesting things can be found. Paint them on the spot or take some home for still life arrangements.

place, mostly in art schools, but they were few and far between. They were special events given for a special purpose, perhaps to raise funds for the school or to celebrate an anniversary. Now painters travel all over the country giving demonstrations for art clubs and societies. I've done my share, seen a lot of America, and met a lot of real nice folks. It's been fun.

Attend demonstrations by what I like to call "name brand" painters. When you do and you're invited to ask questions, ask good ones. An example of a not-so-good question is, "What size brush are you using now, Mr. Pellew?" I probably could do whatever I was doing at the time with several different size brushes. That type of question always comes from the beginner who thinks painting is a bag of tricks and mostly has to do with the tools you use—not so. It's nice to have good tools to work with, but tools alone don't paint the picture—you do. To prove this to a class, I once painted a 16″ x 20″ realistic landscape using only a rag, a stick picked up from the ground, and my fingers.

A good demonstrator talks while demonstrating. By talking, I don't mean sounding off with a lot of artistic doubletalk picked up from the writings of our current crop of art critics. I mean good "down to earth" talk that explains just what's being done at the moment, and why it's being done at that time.

Do's and don'ts of landscape painting

Do select your subject carefully (Figure 29). Don't paint something just because it reminds you of pictures by one of your favorite painters. Select the subject because it strikes you when you come upon it as something worth recording on canvas.

When you're face to face with nature, don't forget that the purpose of painting a landscape is *not* to reproduce nature. You can't do it anyway. Remember to make a personal statement—or at least try.

Don't think that you must have a sunny day outdoors. Gray days make good pictures too.

When you see something that stops you, paint it. Don't keep wandering, thinking that there's going to be something better around the bend. You may end up by doing nothing.

Don't think that you must paint "modern" or "traditional." Just be yourself; be honest.

Never leave a mess where you've been working. Pick up those dirty paint rags. Don't spoil it for the rest of us.

If you think the area may be private, ask permission to paint before you intrude.

Be polite to people who stop to watch, but remember to avoid conversation—they may not leave.

Check your materials before you leave home. To arrive on location and find that you've left your tube of white in the studio is discouraging, to say the least!

Don't keep adding details to your first impression. Try to learn when to stop.

Most important of all, don't be discouraged. We were all beginners once.

Dealing with onlookers

If you paint outdoors, you have to face the fact that people will stop to see what you're doing. The beginner finds this disturbing, but in time learns to take it in his stride. Most onlookers are polite, nice people and often move on with a complimentary word or a cheery good morning. Occasionally an onlooker comes

Figure 29 *When placing a figure in a landscape, give its size careful thought. It shouldn't be large enough to compete with the landscape (A). In the middle sketch (B) the figure might work, but I feel it's too small—what I once heard an instructor call "monkey size." The figure in the last sketch (C) I think is about right.*

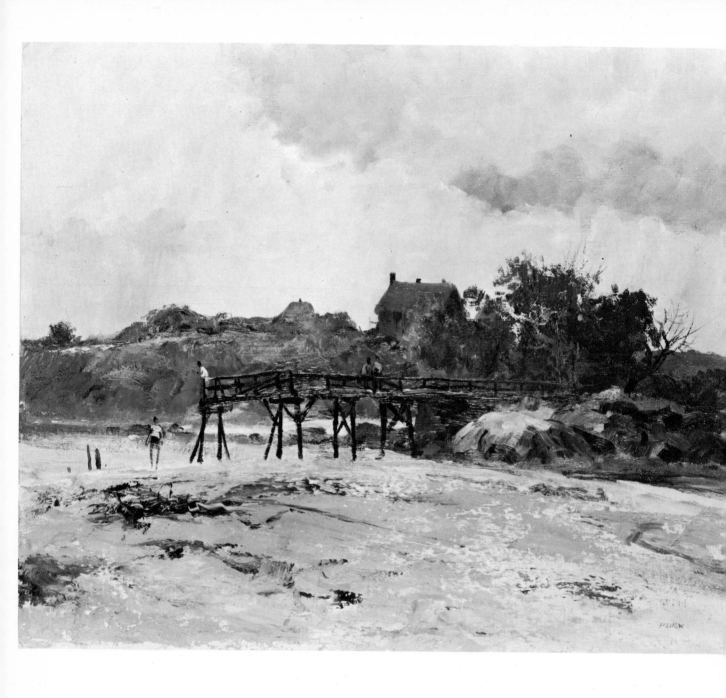

PASSING SHOWER, oil on gesso panel, 16" x 20".

Painted on Good Harbor Beach in Gloucester, the time was late October. I was attracted to the old wooden jetty which had been badly damaged by an autumn storm. It served as good shelter when a brief shower came along. I made use of the cloud even though it had gone by the time I was ready to paint. I tried to suggest the dappled appearance of the sand after the rain. This is best seen in the right foreground. To obtain the effect, I held the palette knife flat against the panel's surface and moved it from right to left. This corner of the beach has been painted many times and at all seasons of the year by painters living in nearby Rockport. Cape Ann still has a wealth of subject matter but it's in grave danger of being spoiled for the artist by tourism and commercialism. It's a shame, but I see the change year by year. I go there in the fall when the crowds have departed.

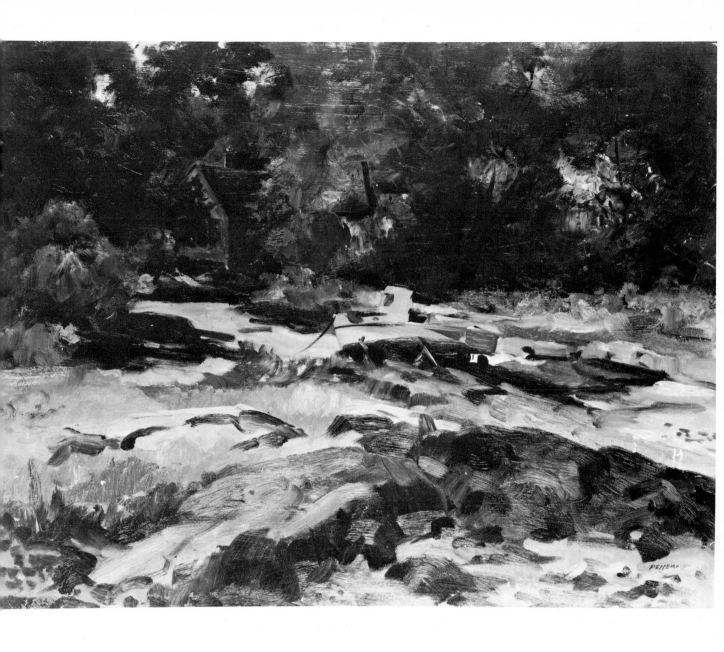

LANESVILLE, NUMBER 2, oil on Masonite, 20″ x 24″.

This is one of a few early examples of my work that I think might be interesting. It's a flatter treatment than I now use. It fits what used to be called the "square brush school." Anyway it's not a bad example of what I was doing about twenty years ago. This picture was more or less painted from top to bottom. I started with the background trees, then the lobster boat, and finished with the big rocks in the foreground. It's strange that it's possible to recall my procedure after all these years. I guess the fact that I stood there that day for a couple of hours and put it down fixed it in my memory. I've already written so much about Lanesville, Massachusetts, there's nothing left to say— except that it's a favorite painting spot on Cape Ann. I hope it never changes. I wouldn't venture to guess how many pictures have been painted there. Artists have visited and worked there for a hundred years. Winslow Homer painted in nearby Gloucester and Rockport, so I think it's safe to say he must have been in Lanesville also—if not to paint, then just to admire its rugged beauty.

117

along and wants to talk—often not about what the painter is doing, but concerning *another* painter he has watched and how good *that* painter was. You meet all kinds.

Is there a way to discourage these characters? Not really. It's best to grin and bear it. The only thing that seems to work is to maintain a stony silence. The intruder eventually comes to the conclusion you're a grouch and leaves. If you enter into any conversation at all, you could be in for a long visit.

I've heard of an English painter who puts his hat on the ground with some coins in it. That may work in England but I doubt if it would here. An artist friend of mine suggests stepping quickly backward onto the onlooker's feet. He claims it works. Another artist says he simply turns and glares fiercely. Personally, I lack the courage for these extreme methods; I use the silent treatment—it suits my character.

Studying paintings

When you look at pictures in museums or study reproductions of works of art, keep an open mind. Don't think that painting stopped with the old masters or started with Picasso. Some of the Victorian painters, both American and English, are worth looking at. Their kind of painting was out of fashion for a long time, but now shows signs of coming back.

When you study the painting of that period, disregard the sentimental storytelling qualities of their subject matter. At their worst, they produced some rather banal illustrations. They also painted a great many fine works.

The British Royal Academicians, painting between 1800 and 1914, were great craftsmen. Even individual parts of their most illustrative works often amaze me. They were magical manipulators of paint; as renderers of textures and detail, they would be hard to beat. Don't forget that our own Winslow Homer was a Victorian. His early paintings of pretty ladies in fashionable costume, strolling on the boardwalk or playing croquet on the lawn, have great charm. Overshadowed for a long time by the great marines of his later period, they, too, are making a comeback.

Exhibiting your work

There's a great deal of exhibiting being done today by both amateurs and professionals. A word or two from an old hand at exhibitions may be helpful. There always comes a time when the talented amateur gets the urge to submit his work to a juried show. If this happens to be a small local exhibition where the level of quality isn't too high, the chance of acceptance is good. This is encouraging; it bolsters the ego and inspires the painter to go on painting. These local, regional shows, held by art clubs and societies, are where the amateur should first try his wings.

When he first sends to the big national juried exhibitions and gets rejected, then doubts and depression set in. His family and friends have had nothing but admiration for his work—so what's wrong? Simply this. The jury is made up of well-known professionals, competent painters with a keen eye for good painting. True, they sometimes make mistakes, but not often. Also, the amateur now has to compete with some of the country's best painters. The picture comes before them "cold" and stands alone to be accepted or rejected. Sad to say, it's more often the latter.

What do you do about it? Nothing. In more than forty years of exhibiting, I've never questioned the action of a jury and I've had my share of rejections. Sure, it's disappointing, but to get heartburn or make nasty comments is futile. The only

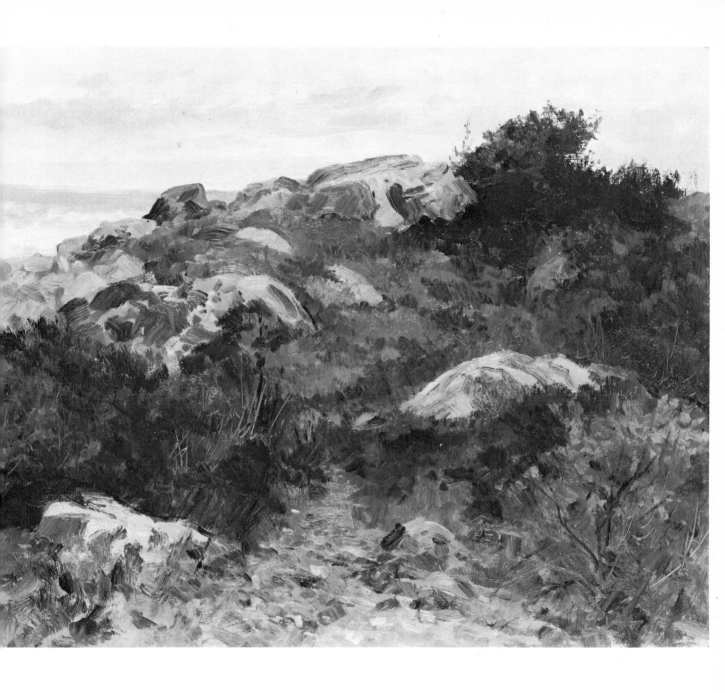

OCTOBER MORNING, BASS ROCKS, oil on gesso panel, 16" x 20".

There's another Bass Rocks painting reproduced in color on page 74. Both were painted the same week from the same spot, but facing in different directions. The one here has more scrubby bushes and fewer rocks than the other, but both suggest the character of that marine painters' favorite haunt. I don't consider myself a marine painter, so again there's not much ocean in view. I also painted a large watercolor from this oil. It was exhibited at the 1970 annual exhibition of the American Watercolor Society where it was awarded the silver medal.

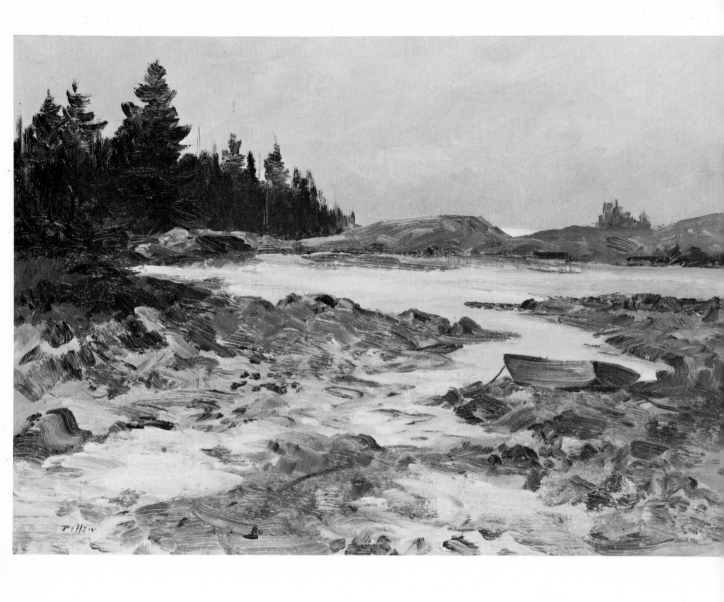

PENOBSCOT BAY, oil on gesso panel, 9″ x 12″.

I'll always be thankful that I'm the kind of painter that enjoys going to nature. I never tire of observing the many moods of wind, weather, and outdoor light. Pictured here is a quiet calm day along a stretch of the Maine coast that I have a particular fondness for. The long finger-like peninsulas that jut out into Penobscot Bay are so paintable. There seems to be a picture at every turn of the road. This sketch was painted on a lazy autumn afternoon when everything was still. The water was so calm, reflecting the light so brilliantly, it almost *had the appearance of a sheet of ice. The foreground grass and weeds had lost the green of summer and the pines on the distant headland stood dark against the sky. After indicating the composition with a few lines, I started at the top and worked down—first the sky, then the headland and water, and finally the large foreground. I think I managed to capture the mood of the day. After all that's what makes a successful impression from nature.*

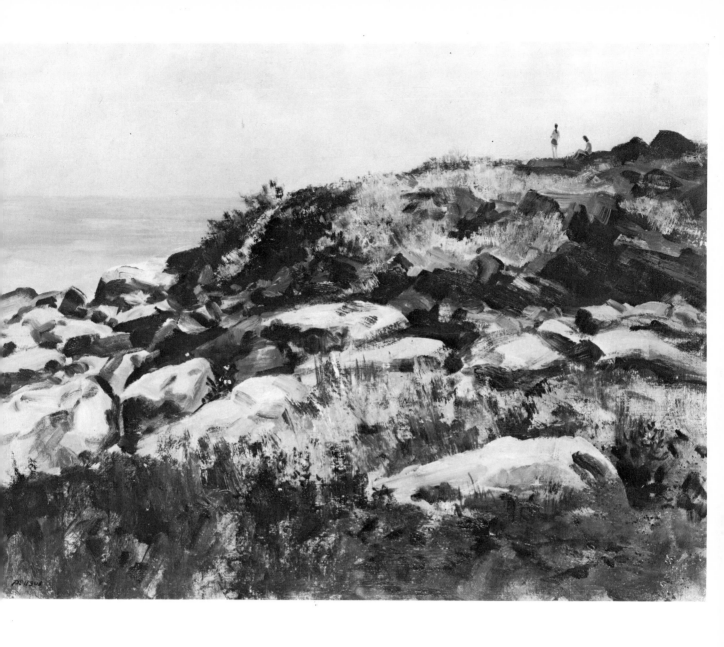

TURN TO THE RIGHT AT LANESVILLE, oil on gesso panel, 18″ x 22″.

Because I grew up on a rocky coast, I always feel most at home near the ocean. I've painted in many parts of the United States and enjoyed them all but the New England coast will always be nearest my heart. This picture is another in a long series painted on Cape Ann. How do you find this particular spot? Well, just go into Lanesville Cove and turn to the right. Walk up onto the rocks and look toward Pigeon Cove and there you are. This certainly isn't very spectacular as a composition, but I think it has the "feel" of that rocky coastline, *and I think I captured the color of that warm, late September day. The time was 11:00 A.M., late for me. I'm usually on my way home by then. The sun was high, causing strong top lights on the rocks. The air was clear, and there were strong shadows present. It's impossible not to paint good solid rocks under such conditions. The two figures were an afterthought. I often put them in pictures of this kind; they set the scale, and tell you how large the rocks really are.*

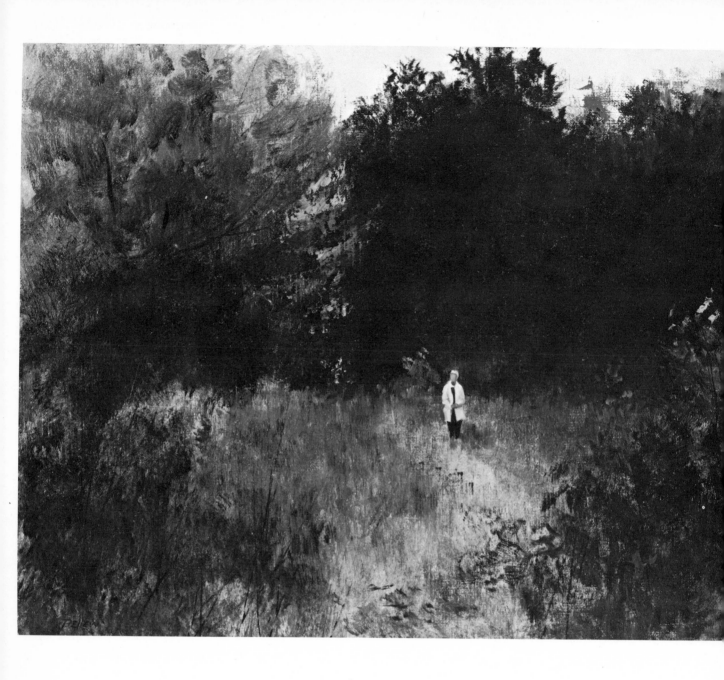

OLD FIELD WOODS, oil on gesso panel, 16″ x 20″.

Although most of the pictures reproduced in this book were painted on the spot, I've included some studio paintings like this one. It was painted from a pencil sketch made one Sunday afternoon when Elsie, my wife, and I were taking a walk through the fields and woods of Westport's Youth Museum. Those fields have served me well. They're situated a short drive from my home and I often go there— sometimes to paint and other times just to walk and observe nature. These fields consist of about sixty-five acres of old farm land, with nature now taking over what was once cultivated land. Most of these wooded areas are what New Englanders call, "old field woods." There's a great deal of this type of country in Connecticut. Here again is my favorite model wading through the knee-high autumn grass and weeds. Note how the composition has been designed to lead the eye to the figure which, placed just off center, becomes the single dominant point of interest. The color is that of early October. The trees have just begun to turn, but the grass is already in its full autumn color—ochre, pink, and a rich golden yellow. I owe a lot to the kind people who left that tract of land to the town of Westport.

sensible thing to do is to go on painting. If you can't take rejections quietly, don't send your pictures to a jury. However, it's a well-known fact that a picture rejected by one jury may be accepted by another. So roll with the punch. The next picture is always going to be the best yet; and after all, it's painting the picture that's the most fun.

Are there good and bad exhibitions? That's such a personal matter that it's impossible to answer seriously. There's a tongue-in-cheek kind of answer—but don't take it seriously. If your painting is rejected, it's a bad exhibition. If it's accepted, it's a good exhibition. If you've won an award, it's the best exhibition held in years! When you're fortunate enough to have a painting accepted, don't quibble if it's not hung in the main gallery or on the best wall. If the painting is good, it will be seen.

The present jury system is far from perfect. Some of the big annual exhibitions will have a seven-man jury, while others will invite one man, often a museum director, to be the jury. The exhibition juried by one man represents one man's taste and prejudices. I prefer the seven-man deal myself. In my opinion, the worst combination is the three-man jury of selection, where two jurors often gang up on the third.

The jury system leaves much to be desired, but it's all we have. If you must exhibit, you'll have to go along with it and remember not to cry when you get hurt.

The artist's life

Why do so many people want to paint pictures? I don't know. There are certainly better ways of making money. Perhaps being a painter, struggling year after year to paint a better picture, is the sign of a one-track mind. I don't mind if it is. I wouldn't have missed it for anything. Just thinking about that next picture, the one that's going to be so good, is to experience a feeling, or a thrill if you like, that just can't be put into words.

At the end of the day's work you bring your painting in from the fields, set it on the easel, and after some quiet contemplation, you know that what you painted was worthwhile—you've done well. That's a nice warm feeling. So, with its ups and downs, the art life is a good life, and as Robert Henri put it, "The only sensible way to regard the art life is that it is a privilege you are willing to pay for."

I've enjoyed it. Along the way, I've had help and advice from my teachers and fellow artists, for which I'm most grateful. Most of all, I have to thank my wife Elsie, not just for typing the manuscript of this book and two others, but also for her patience and fortitude over the years. If I've accomplished anything, certainly part of the credit is due to her.

PORTLAND HEAD, oil on watercolor paper, 16" x 20".

A pencil note on the back of this picture tells me it was painted in 1947. At that time I'd just discovered the state of Maine and was in love with its rockbound coast from the start. I was living in New York City then, so to get to Maine for a week or two of painting was almost like going back to Cornwall, England. This painting appeals more to me now than it did twenty-four years ago. I remember the day quite well. I had driven down to Portland hoping to find surf crashing against the rocks. There was none. The sea was calm and the rocks hot in the summer sun. In those days I'd yet to learn that the breaking wave thing had been

overdone. Anyway, to be done well it must be done by a specialist in marine painting. There's no such thing as learning to paint marines in ten easy lessons. So, I was disappointed and now I'm glad I was. If the surf had been rolling in, I would have painted the obvious, and if I've learned anything these past years it's not to paint the obvious. Because the dashing surf wasn't there I painted the rocks and ledges. I think the result was a strong picture with some mighty solid rocks. It was painted on 300 lb. watercolor paper that had been pre-toned with a thin coat of gray oil paint.

Demonstrations

A WET DAY, ROCKPORT: *Step 1*

This has been my usual start. I sketched in the composition using a brush and burnt umber thinned with turpentine. The panel, of course, had been pre-toned with a gray wash. When painting a view of the ocean be careful where you place the horizon. Never place it through the center of the space, dividing it in half. Always put it well below or well above the center. As you can see I chose the latter. I designed the tidal pool to lead the eye into the picture and to the little building perched on the rocks.

A WET DAY, ROCKPORT: *Step 2*

Now I hurried to cover the panel as quickly as possible. Starting with the sky, I moved down through the picture establishing the darks of the headland and its reflection in the pool. The beach was composed of thickly applied broken color—mostly cadmium orange, burnt sienna, and cerulean blue—all very loosely mixed on the palette with white. In the pool I've also placed the picture's lightest light and darkest dark. The upper parts of the rocks, the wall, and the summer house—the "folly" or whatever you care to call it—are the only spots left uncovered.

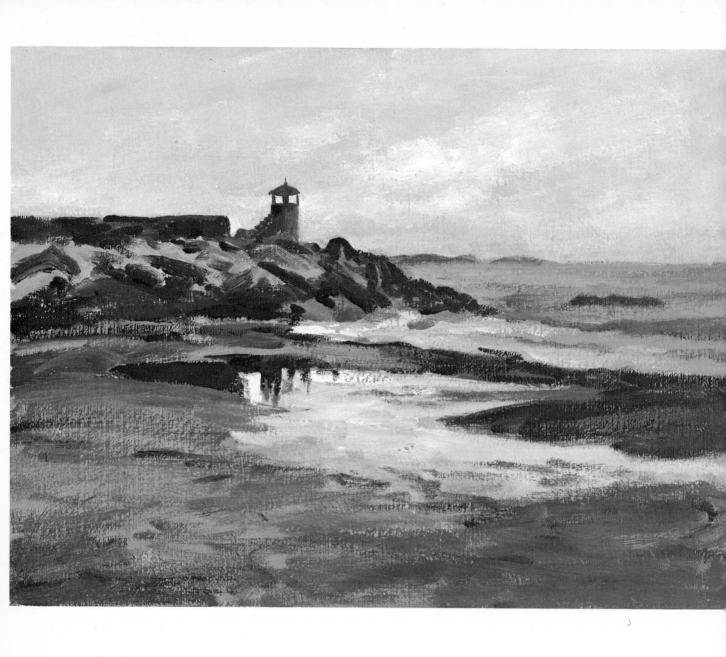

A WET DAY, ROCKPORT: *Step 3*

Here I've finished the sky with a few light tones in the clouds, then I developed the rocky headland with its wall and little building. The rocks were given form with strong top lights of yellow ochre and burnt sienna. Most of the rocks on this section of the coast are ochre in color. This step shows the picture almost finished. The lady and her dog were the last things painted (see color reproduction). She came along just in time—thank you, ma'am.

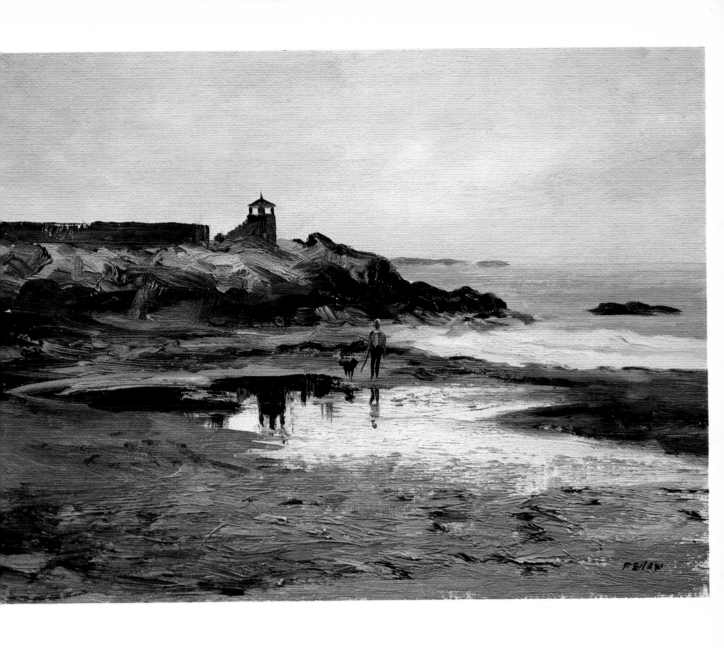

A WET DAY, ROCKPORT, final stage, oil on canvas panel, 9″ x 12″.

It's possible to pass a place hundreds of times and not see it as a painting subject. I've painted in and around Rockport, Massachusetts, for many years, but this outcropping of rock with the cute little "folly" perched upon it had no appeal whatever. The trouble was that I'd never seen it in the right kind of weather. On a bright sunny day when the sky is blue and the ocean a deep ultramarine the effect is pure "postcard." However, the day this was painted was something else. The rain had stopped; the clouds were being blown out to sea. The outgoing tide had left large puddles on the beach which were acting as perfect reflectors. Even though this was a place well known to me, it was a new experience. The weather had presented me with a new picture. It's true that nature seldom presents us with a ready-made composition, but in this case there were few things to change. I made the puddle larger and the "folly" smaller than they actually were—that's all. The lady walking her dog was a lucky break; she helped to set the scale of the scene. So you see, it pays to keep your eyes open, ready to observe at all times.

SKUNK CABBAGE AND MARSH MARIGOLDS: *Step 1*

This picture was painted in a bit of swampy ground not far from home. I sat on a level with the plants to do it. You really have to get close to your subject to do a closeup. It was very uncomfortable. That's the reason it was mostly painted with a palette knife; the knife is quicker than the brush. In this step I toned the panel with my usual warm gray mixture of raw umber and white. My drawing of the skunk cabbage was a bit more definite than my drawing would be for a straight landscape. I didn't want its shape to get lost in the thick paint I was about to use.

SKUNK CABBAGE AND MARSH MARIGOLDS: *Step 2*

Now using only the palette knife, I started painting around the plant, indicating background, rock, and foreground. My greens were mixtures of cadmium yellow light and thalo blue. The grays of the rocks were obtained with mixtures of cerulean blue, cadmium orange, and burnt umber with white. In the foreground, where there was a mixture of twigs and last year's leaves warm color was needed. For this area I used burnt sienna with the grays that I'd already used in the rocks. The patch of intense blue (thalo) at the far right reflecting the sky was put in. Then I was ready to paint the charming wild plants that first attracted me to this spot.

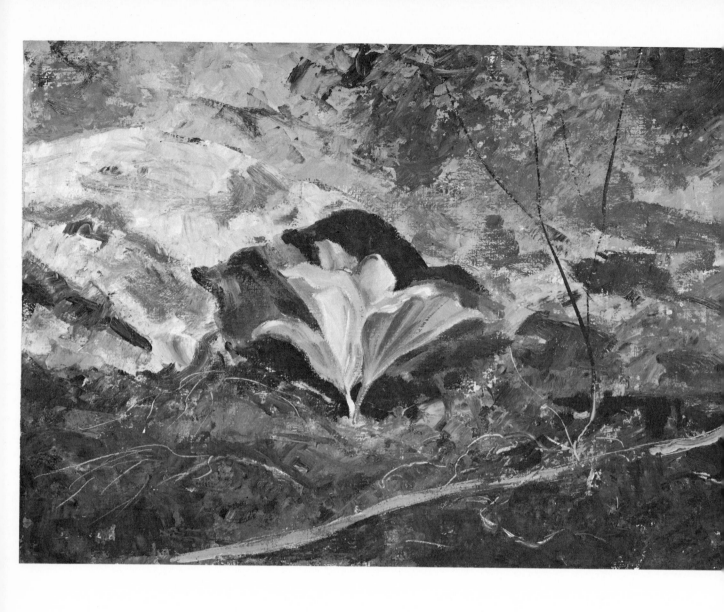

SKUNK CABBAGE AND MARSH MARIGOLDS: *Step 3*

Here I turned my attention to the skunk cabbage and developed its form with greens consisting of cadmium yellow and raw sienna in mixtures with thalo blue (very little) and white. For the dark side of the rock behind the plant I used burnt umber, thalo and cerulean blue, and some white. The plant itself was painted with brushes. Then came the business of developing the detail—mostly in the foreground. To suggest twigs, etc., I dragged the point of the knife through the thick paint and added other branches with a small, pointed sable brush. The marigolds were the final touch (see the color reproduction). I used cadmium yellow light straight out of the tube, and put them in with my pointed sable.

SKUNK CABBAGE AND MARSH MARIGOLDS, final stage, oil on canvas panel, 10″ x 14″.

A walk through the woods and swamps in spring can be most rewarding for the painter. An intimate closeup of a bit of woodland floor can be as interesting as a view of an extensive landscape. As I walk through the woods I see a lot of good material to paint: old tree stumps, patches of moss mingled with last autumn's fallen leaves, and brave young saplings pushing up toward the light. All these are good to paint. In the spring, there are wild flowers, and they're the best of all. The only drawing I did for this painting was to sketch the skunk cabbage and indicate the big rock behind it. Then, I went to work with the knife, starting at the top and working down, putting in warm and cool tones of green and gray. There was no attempt to define detail until the panel was completely covered. Then I painted the skunk cabbage with a brush and suggested the foreground detail. The perky little yellow flowers were the last things painted. Having crouched in marshy ground for an hour, I headed for home, with one foot wet and the seat of my pants damp. But when it's spring—who cares?

EARLY MORNING, WHITE MOUNTAINS: *Step 1*

Since only the lower part of the sky was exciting in its light, color, and cloud formation, I decided to compose this painting with a high horizon. The line at the base of the dark trees was the first thing drawn. With some lines indicating the mountain tops and the top of the trees, and a few squiggles in the vast foreground, my composition was all set. The landscape student that indulges in finicky drawing at this stage is wasting his time.

EARLY MORNING, WHITE MOUNTAINS: *Step 2*

Because the sky was changing rapidly, it was the first thing I painted. I don't remember using anything but cerulean blue, cadmium orange, and a little alizarin crimson (just above the distant range) with white. I used the same colors and added thalo blue for the mountains. Next came the dark trees. This almost black-green was obtained with a mixture of thalo blue and raw sienna. So far this had all been brushwork. The palette knife didn't come into play until I began to work on the rugged foreground.

135

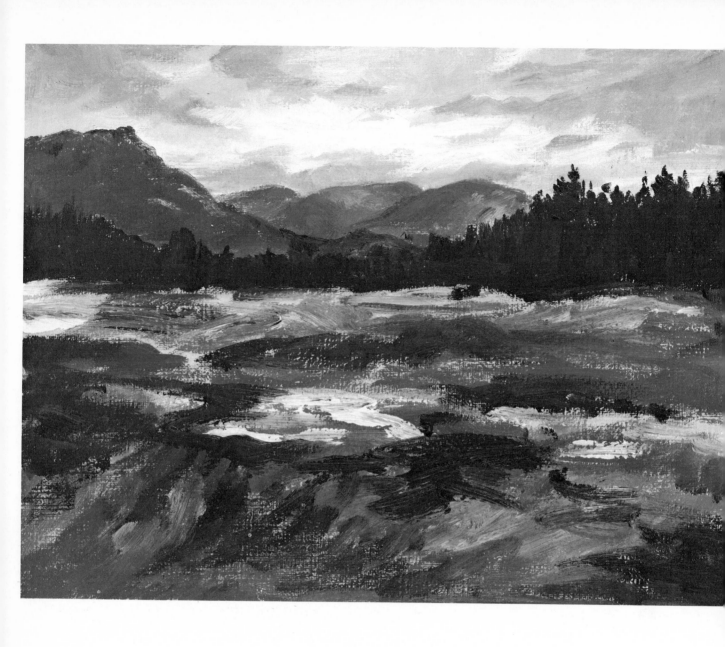

Early Morning, White Mountains: *Step 3*

Using the knife, I started painting my foreground. Here I loosely mixed yellow ochre, raw sienna, burnt umber, and thalo blue with white. Most of this area was still in shadow although the stream that was flowing from right to left across the middle (halfway between the picture's bottom edge and the base of the dark trees) was catching some light. At this point I used a brush to push the thick paint around, suggesting form and adding textural interest. With a few weed stalks in the foreground—some scratched in with the brush handle, some painted with a small, pointed sable brush—the picture was finished (see color reproduction).

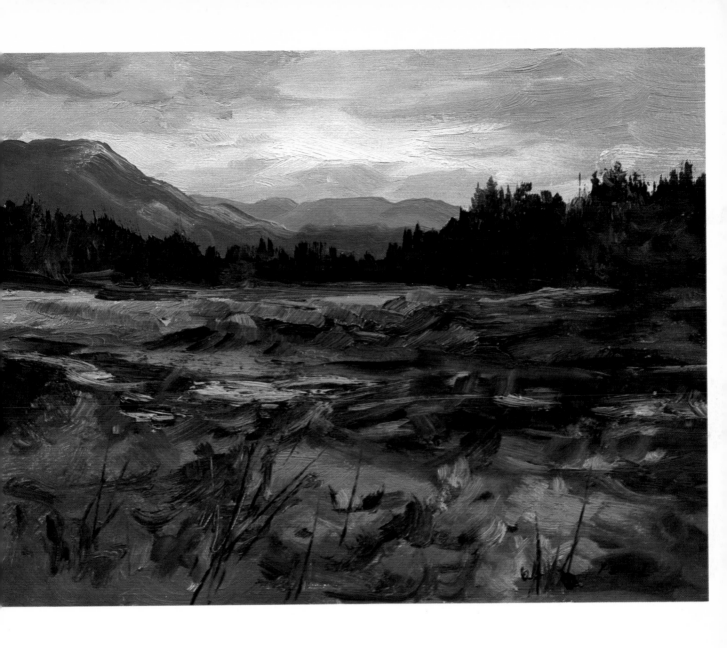

EARLY MORNING, WHITE MOUNTAINS, final stage, oil on gesso panel, 9″ x 12″.

Getting up before dawn to go painting is a tough assignment, but I've done it. The landscape can be very beautiful just at sunrise. If you're a serious student of landscape painting you should try it, even though you do it only once. In this painting is a part of the Presidential Mountain Range in New Hampshire where I've painted on and off for many years. The sky and distant mountains are the point of interest and they've been made the colorful part of the picture; they were anyway. The whole large foreground was in shadow when I was there, and I tried to match the values exactly while simplifying the detail. Knowing that the cloud forms would change, I studied them carefully for a minute or two then rapidly painted them in without looking at them again. Then, I put in the mountains. There was very little change taking place in the foreground, so I finished the mountains and the dark band of trees. By that time the large foreground field was getting some light. I decided it would have to be painted in very close values, just as I saw it. You shouldn't change the light in your picture as it changes before you in nature. Stick with your first impression.

MOUNTAIN STREAM: *Step 1*

I've painted this demonstration on a commercially prepared canvas panel, because, having been far from home, I'd run out of my own self-prepared kind. I toned the surface with a mixture of white and burnt umber thinned with turpentine and allowed it to dry overnight. My drawing was merely an indication of the stream's far bank and the position of the fallen treetrunks. Then, with a few more lines I placed the foreground rocks and I was ready to start painting.

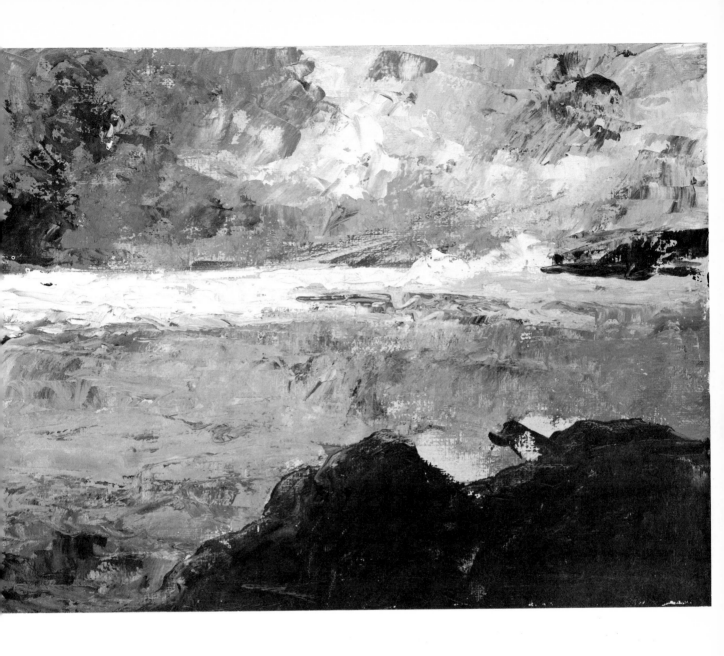

MOUNTAIN STREAM: *Step 2*

The paint was thickly applied here with the palette knife. Thinking of color and light, not of details, I started with the forest background. For these warm and cool tones I used cerulean blue, cadmium yellow light, raw sienna, and a little thalo blue. They were all loosely mixed and put down over and into each other, creating a variety of tones and textures. Next, the sunlit part of the stream just below the bank was painted with the knife. Then, the main body of water was done in blues and greens, still using mixtures of the colors mentioned. The dark foreground rocks went in next. For these dark tones I used thalo blue·and burnt umber dragged into each other with knife and then troweled on without much mixing.

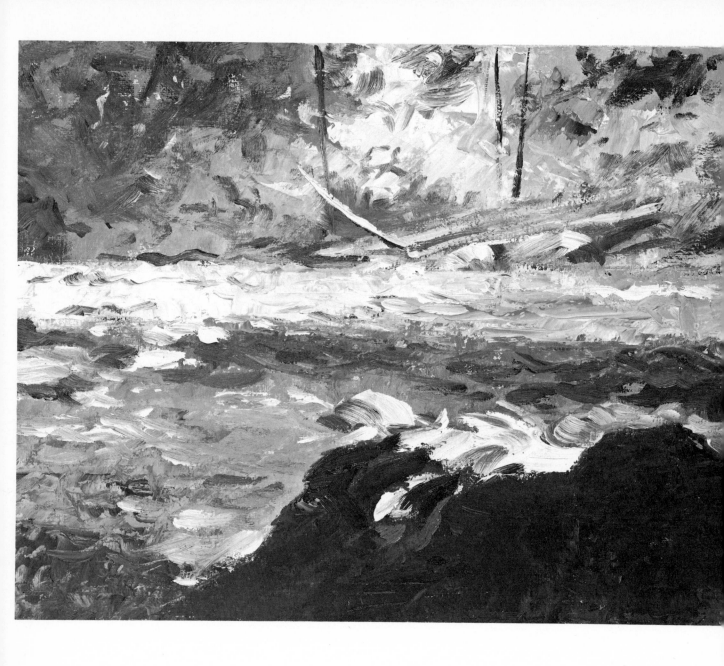

MOUNTAIN STREAM: *Step 3*

I started adding detail here. With a brush I indicated treetrunks among the foliage and the fallen trees on the rocks at the water's edge on the far bank. Using the brush with a downward stroke through the thick paint, the trunks went in with one stroke each. Picking up the palette knife again I went to work on the stream. With the brush I worked through the paint that had been applied with the knife to produce the waves and ripples that occurred in the swiftly moving water. I painted the water dashing against and over the foreground rock and put some top lights on the rocks. A touch or two here and there and the final result can be seen in the color reproduction.

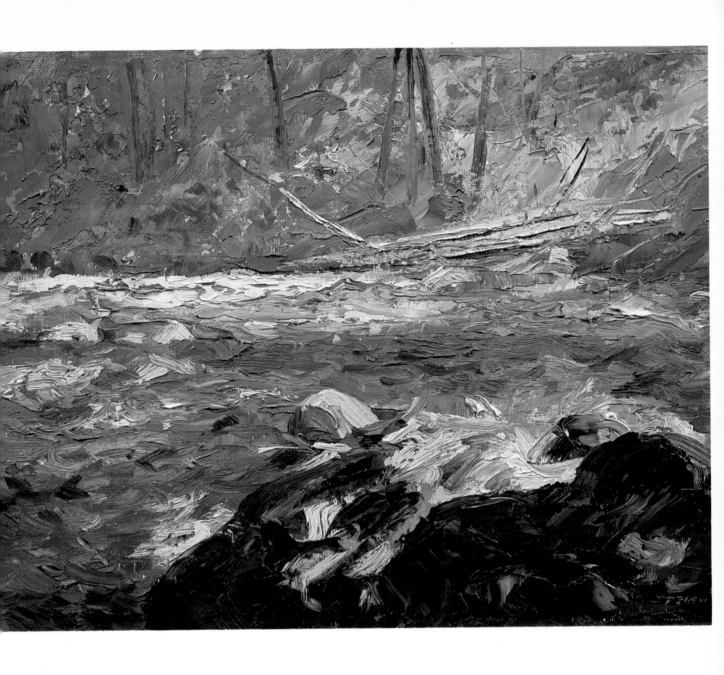

MOUNTAIN STREAM, final stage, oil on canvas panel, 9″ x 12″.

What landscape painter doesn't thrill to a mountain stream? I know I do. I first painted them in New Hampshire and more recently in Colorado. I love the patterns created by the swift water swirling around and over the rocks, the brilliance of the foam in sunlight, and the cool color of the same in shadow. In London's Tate Gallery, one of my favorite paintings is a study of a mountain stream by John Singer Sargent. It's broadly painted with a large brush. Close up it's paint, but back away a few feet and you see one of the most wonderful interpretations of sunlight you've ever beheld. What an eye that man had! This picture was painted in Colorado. In it, I tried to convey the feeling of swift water and sunlight. I worked rapidly in order not to lose my first impression. There was some brushwork but not much. Most of it was painted with the palette knife.

ST. IVES: *Step 1*

The panels that I paint on outdoors are always toned, never white. Long ago I found that a white surface could be very disturbing. One of the problems it causes is the inability to judge tonal values correctly because of the pure white background. The panel for this picture was pre-toned with a gray mixture of white and raw umber. This step shows my composition sketched in with the brush and burnt umber thinned with turpentine.

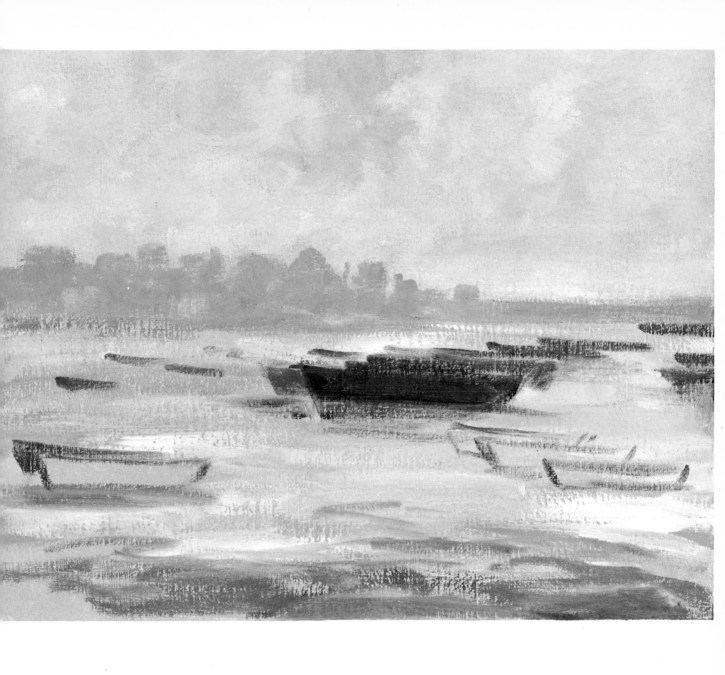

St. Ives: *Step 2*

Here most of the ground had been covered, but no attempt was made to finish any one part. The sky and the distant town were painted with mixtures of cerulean blue and cadmium orange, a favorite combination I often use. The broken color of the harbor, with its pools left by the outgoing tide, was the next thing painted. In this area I used the favorite combination mentioned plus yellow ochre, burnt and raw siennas, and a touch of thalo for some clear cool blue in the foreground. The fishing boats in the center were roughed in using combinations of burnt umber, burnt sienna, and cerulean blue.

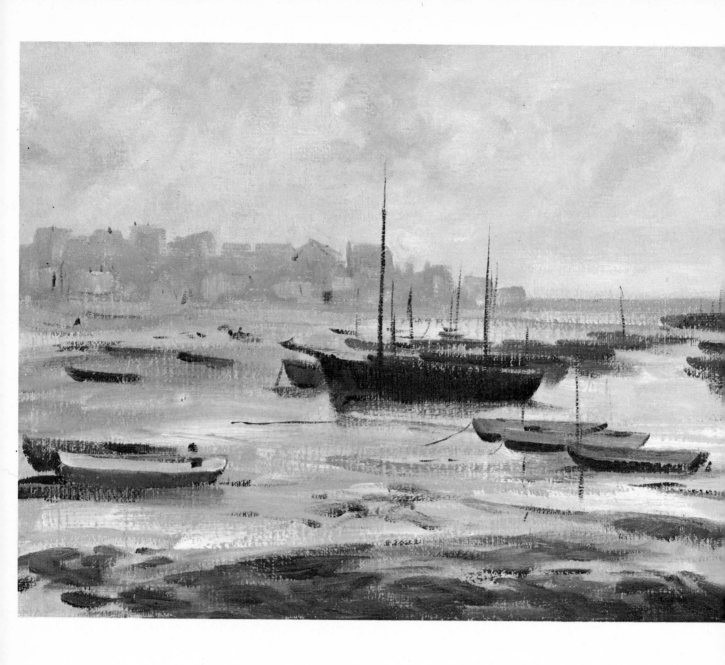

ST. IVES: *Step 3*

*Here's the beginning of the final step—always a crucial moment. This is when the
artist must decide how far he can go with detail. It must be enough to create
an illusion of reality but not enough to spoil the first impression. In this picture
I was trying to show the old town in the haze of a summer morning; so I simpli-
fied the detail, omitting much that I saw, such as the boats' rigging and the many
windows, doors, etc. in the distant houses. This time I think I did what I set out
to do (see the color reproduction). If I hadn't, you wouldn't be seeing it now.*

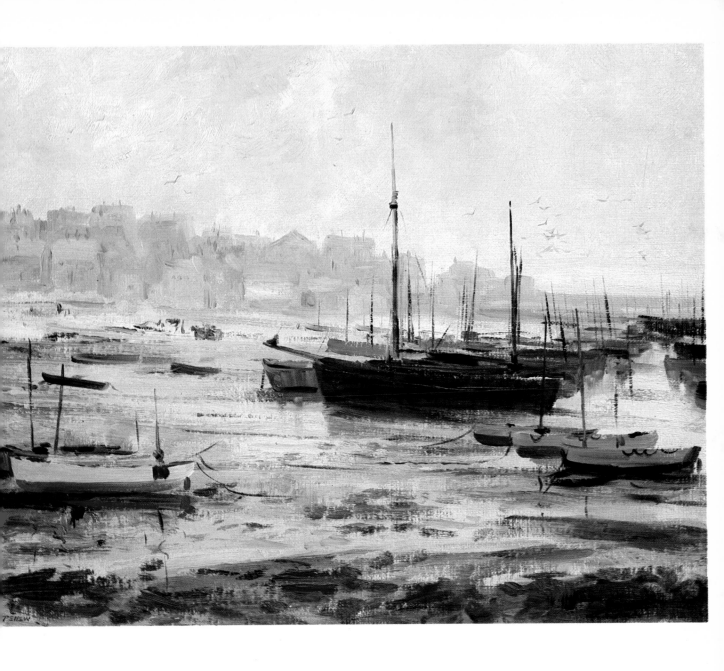

ST. IVES, final stage, oil on gesso panel, 14″ x 18″.

This fishing town on the coast of Cornwall, England, has been an art colony for perhaps a hundred years. Its narrow picturesque streets, busy harbor, white sandy beaches, and its rocky cliffs have been the subject matter for thousands of paintings. Whistler was there and so was the great Scandinavian, Anders Zorn. The American painter Frederick Waugh painted his first marines there, and Paul Dougherty, another American, painted his fine Gurnard's Head on the cliffs west of the town. The painters have proven to be great publicity men for St. Ives. The tourists started arriving at the turn of the century and have been increasing ever since. It's almost impossible to move in the old town at the height of the season. Having grown up near St. Ives, I visited it often when I was a boy. I loved the place in autumn and spring before the "visitors" arrived. It was then I could see the artists at work around the harbor and in the streets. In my book Painting in Watercolor *I've told how seeing the painter Charles Simpson at work proved to be a turning point in my life. Much of the luminous quality present in this painting is due to the use of broken color which I've explained in Chapter Six.*

THE SUN IN THE MORNING: *Step 1*

For this picture I selected a panel pre-toned with a mixture of white and burnt sienna thinned with turpentine. It was quite transparent, allowing the gesso ground to show through. The big, main pattern of my composition was sketched with a brush and burnt umber diluted with turpentine. Three areas were established—foreground, middle distance, and distance. These had to remain in the finished painting no matter how much detail was superimposed.

The Sun in the Morning: *Step 2*

With the palette knife and plenty of thick, rich color I began building up the three main areas. There was still no detail, just contrasts of warm and cool color to establish the sunlit and shadowed parts of the composition. For the sun-splashed center I used cadmium yellow light with white. In the foreground the reds, blues, and brown were put down in broken tones, loosely mixed on the palette. The side of the house, barely seen in the completed picture, was painted in with a brush using a cool gray—a mixture of white, cerulean blue, and cadmium orange. Some foliage was roughed in with cadmium yellow, raw sienna, cadmium red, burnt sienna, and some thalo blue in the darkest part. This was all painted with the palette knife.

147

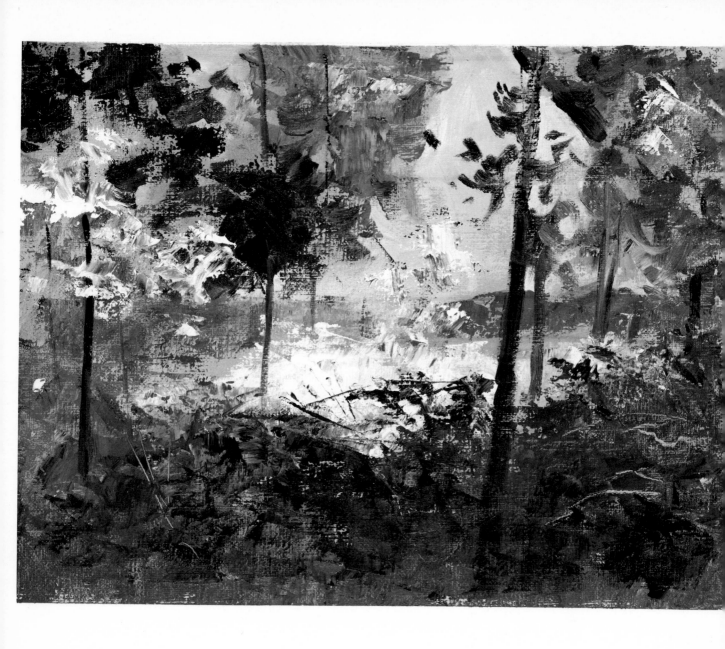

THE SUN IN THE MORNING: *Step 3*

Here I began to suggest reality in what up to this point had been an abstract design. At the start, I had placed my main treetrunk rising out of the foreground. Others now went in, some where they happened to be in the scene before me, others where I wanted them to be. Next came branches and twiggy indications in the foreground. Some were scratched into the wet paint with the point of the knife; others were painted with a small, pointed sable brush. From here on it was a matter of just doing enough to create an illusion of reality without destroying my first impression. You must learn when to stop. How far I went can be seen in the color reproduction. No colors other than those listed were used. I mixed resin gel with the mounds of paint on the palette, but no gel was used while painting.

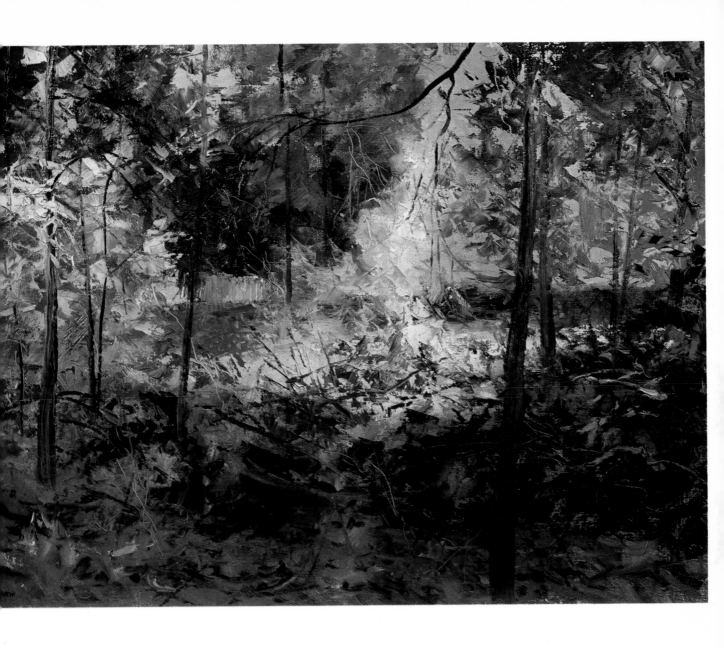

THE SUN IN THE MORNING, final stage, oil on gesso panel, 18″ x 24″.

Looking east from my kitchen window this is what I saw around breakfast time on a fall morning. The sun had risen from behind Jack Bender's house and its light, streaming through the autumn foliage, turned the space between our two houses into a curtain of crushed jewels. This picture is one of the many attempts I've made to capture the effect of that brilliant light. Manet is supposed to have said, "The most important person in a painting is the light." How right he was. A landscape painting lacking the illusion of light might be interesting in design or even color but it won't be an impression of nature. How do you create the feeling of light in a picture? Like Winslow Homer I could answer, "I just paint what I see." That, of course, wouldn't be true and I'm sure Homer knew it. No painter paints exactly what he sees. His experience, training, early influences, and knowledge of the works of other painters are all at work in his subconscious while he thinks he's putting down "just what he sees." If I'd never seen an impressionist canvas, I probably wouldn't have painted this one. The thick, rich palette knife textures I owe to my study of John Constable, especially his full sized sketch for The Leaping Horse *in London's Victoria & Albert Museum. To paint the illusion of light you must first see how others have done it; then go to nature. That's the answer.*

JANUARY THAW: *Step 1*

I've always toned my panels ahead of time—some with warm or cool grays, others with burnt sienna. This one was toned with a gray obtained from a mixture of raw umber and white. In this step, the main lines of the composition were sketched in directly with the brush and a little burnt umber thinned with turpentine. Note the big, sweeping curve that leads the eye from the foreground first to the left then to the right through the composition.

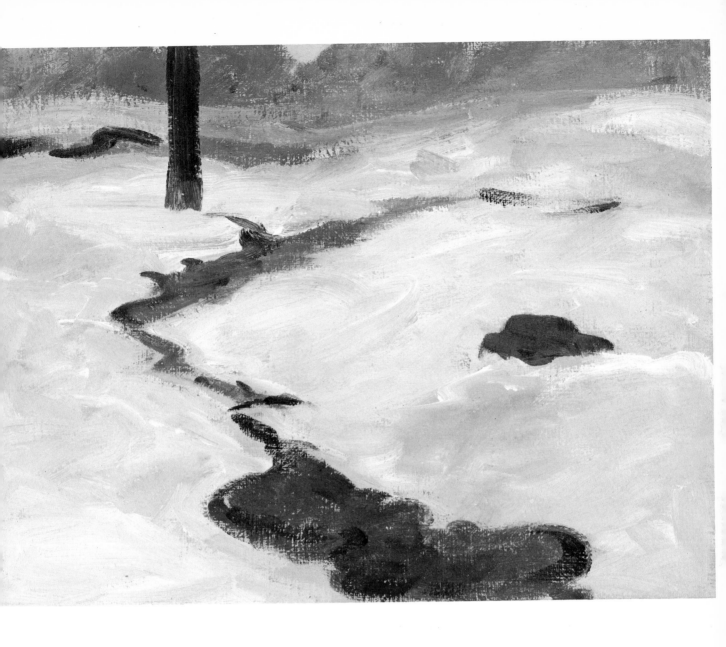

JANUARY THAW: *Step 2*

Here I put in the gray tones of the distance, being careful to leave a tiny patch of sky. I used grays obtained from mixtures of cerulean blue and cadmium orange with white. Next I established the large snow areas on both sides of the brook with a well-loaded brush and bold strokes. My colors were white, burnt umber, and cerulean blue. This done, the dark pattern of the brook, merely an undertone of browns and grays, went in. Now the large tree and the rock balancing it were positioned.

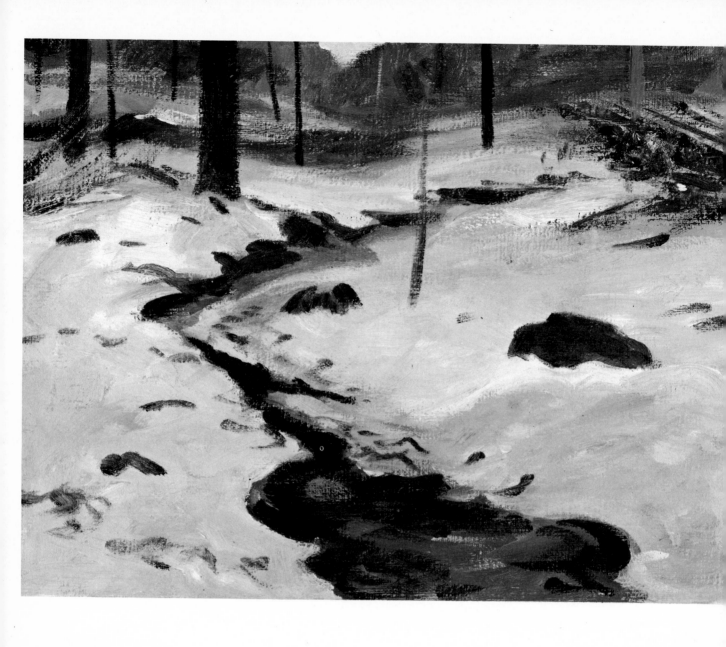

JANUARY THAW: *Step 3*

With this step I took a good look at the landscape before me to seek out significant detail. I started putting in treetrunks not necessarily where they were in nature but where I thought they should go to create a good composition. Actually there were many more than I used. After my bird sanctuary—the brush pile —was indicated in the upper right, the sketch was ready for the finishing touches which can be seen in the color reproduction. In particular, notice the warm touches of raw sienna suggesting last year's fallen leaves in the brook bed. The only additions I made to the snow were a few highlights of pure white—the only knife work in the picture.

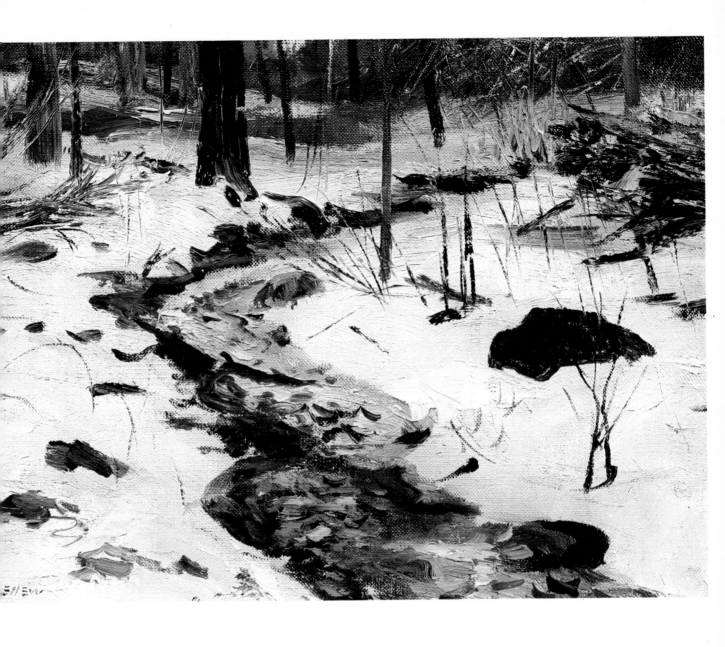

JANUARY THAW, final stage, oil on canvas panel, 9″ x 12″.

If this little picture conveys the feeling of a very cold day, it only proves that even landscape painters will depart from the truth now and then. There had been a long spell of cold weather, and although I had looked on the snow covered land with wonder and awe, I had no desire to get out into it to paint. It was just too cold! So I did what other snow painters have done before; I waited for the weather to warm up. I knew it would because in New England we get the January thaw—a kind of false spring that doesn't last long. The day I painted this picture the temperature had climbed to 45°, ideal for working outdoors. The day was overcast for which I was thankful—no cute, blue, cast shadows. I worked for only half an hour. In the upper right you can see the corner of the brush pile featured in Winter Brush Pile *reproduced on page 72. Here's a couple of clothing tips for the snow painting novice. If you suffer from cold hands wear mittens (not gloves). Cut a hole in the palm and push the handle of the brush through it. Wear two pairs of socks—a heavy woolen pair over a thin silk pair. Courage! Snow painting is not for sissies!*

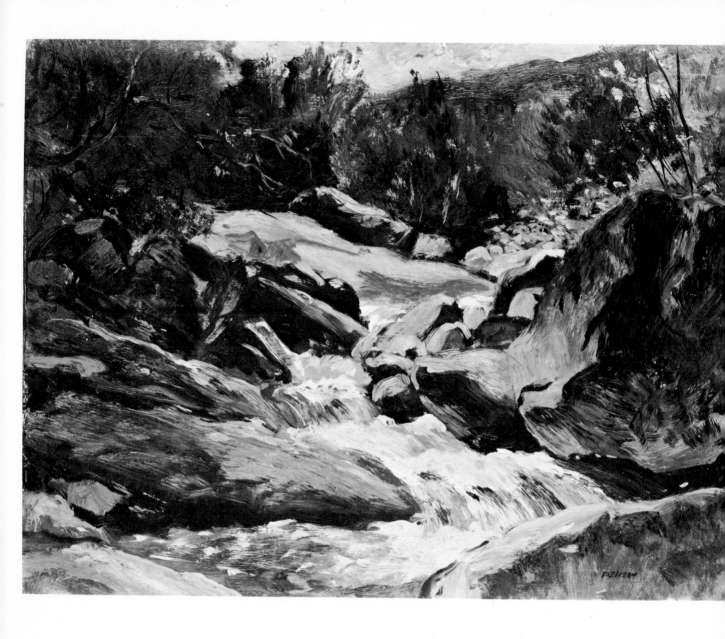

LITTLE RIVER, NEW HAMPSHIRE, oil on Masonite,
12″ x 16″.

In this book, I've included some of my earlier work. Here's an example painted twenty-five years ago on the stream bank just below our rented cabin. I think the bold brushstrokes that follow the form of the rocks clearly show the influence that Robert Henri and George Bellows had on me at that time. My friends tell me my work is more subtle now. Perhaps, but I still like this sketch. I've kept it by me to serve as a reminder of a place I've dearly loved. Students might study the direction of my brushstrokes in the rushing water. Notice how they clearly indicate the direction in which the
water is flowing. Also note the great variety of rock shapes—large, small, and in-between. When painting a mountain stream never settle for three or four rocks; always use many, or maybe none at all. I guess all painters keep a few old works around. Just looking at this brings back the morning I painted it. I almost hear the water splashing around and over the rocks. A little girl was sent by her mother to tell me it was time for lunch. Since that day that little girl has made me a grandfather three times over.

154

Suggested Reading

Here are a dozen books that can be read with enjoyment and profit by the student of landscape painting.

Baskett, John, *Constable Oil Sketches*, Watson-Guptill Publications, New York, 1966.

Carlson, John F., *Carlson's Guide to Landscape Painting*, Sterling Publishing Co., Inc., 1958.

Craven, Thomas, *Men of Art*, Simon and Schuster, Inc., New York, 1951.

Henri, Robert, *The Art Spirit*, J. B. Lippincott, Co., Philadelphia, 1960.

Holden, Donald, *Whistler Landscapes and Seascapes*, Watson-Guptill Publications, 1969.

Leslie, C. R., *Memoirs of the Life of John Constable*, The Phaidon Press, London, 1951.

Mayer, Ralph, *The Artist's Handbook of Materials and Techniques*, The Viking Press, New York, 1957.

Seago, Edward, *A Canvas to Cover*, W. Collins and Sons, Ltd., London, 1947.

Shipp, Horace, *Edward Seago, Painter in the English Tradition*, W. Collins and Sons, Ltd., London, 1952.

Stokes, Adrian, R. A., *Practical Landscape Painting*, Dover Publications, Inc., New York, 1956.

Taillandier, Yvon, *Corot*, Crown Publishers, Inc., New York, 1967.

Wilenski, R. H., *English Painting*, Hale, Cushman and Flint, Boston and New York, 1950.

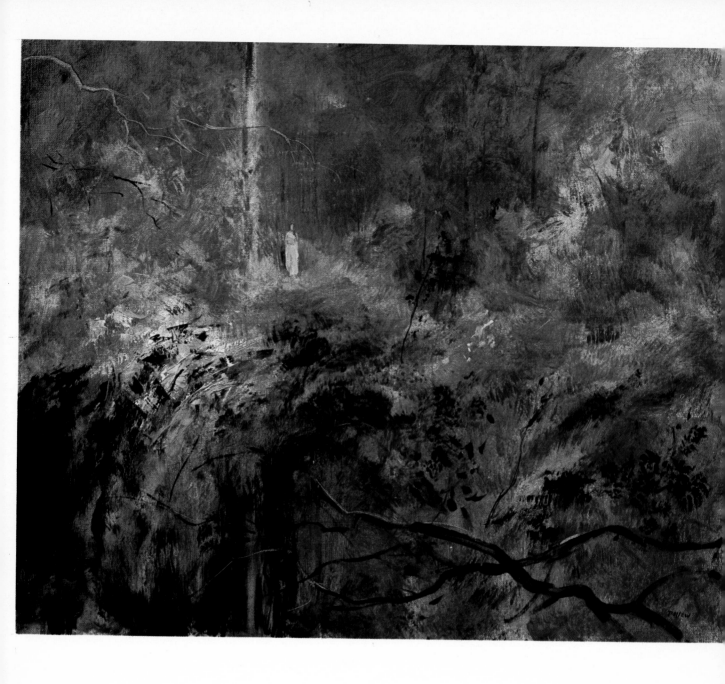

GUINEVERE, oil on gesso panel, 24″ x 30″.

I sure was in a romantic mood when I painted this one. I had recently seen the movie Camelot *and for days I had visions of King Arthur's lovely but unfaithful queen meeting her lover Lancelot in the forest. Something had to be done about it. I had to get that woman out of my system—so I painted the dream. Now Guinevere waits forever among the trees. Of course this is a studio painting. It was done, as the Madison Avenue boys say, right off the top of my head. There were no sketches or preliminary drawings, just a large white surface, some paints, and me. For the first couple of hours it was quite abstract. I put in tones of light and dark with a brush, rubbed here and there with a rag, and did some wiping out. Next, came the darkest darks in the left foreground, and last, the dark branches and, of course, my lovely lady Gwen. Although most of my painting is done outdoors, I enjoy doing this kind of thing now and then. I'm sure a painting of this type wouldn't be as successful if the artist hadn't gone to nature and painted the autumn woods many times.*

Index

John C. Pellew is one of the best-known contemporary American artists, a versatile painter in watercolor, oil, and now in the new acrylics, the winner of many distinguished awards. His work has been included in major national art exhibits since 1934, and he is represented in the permanent collections of museums and galleries from Maine to Brazil. He is a frequent workshop instructor, and is on the staff of the Famous Artists School. Mr. Pellew was born and received his art training in Cornwall, England. He is a member of The National Academy of Design, The Allied Artists of America, The American Watercolor Society, and The Salmagundi Club.

His awards include the Allied Artists Gold Medal for Watercolor, 1951; Gold Medal for Watercolor, Hudson Valley Annual, 1954; Marine Painting Award, Connecticut Watercolor Society, 1958; The Adolph and Clara Orbig Award, and The Henry W. Ranger Purchase Award, National Academy, New York, 1961; Butler Award, American Watercolor Society, New York, 1964; and the Syndicate Magazine Gold Medal, Allied Artists of America, 1967.

His paintings hang in The Metropolitan Museum of Art, New York; The Brooklyn Museum, Brooklyn, New York; The Unio Cultural, Sao Paulo, Brazil; The Georgia Museum of Fine Arts, Athens, Georgia; The Butler Institute of American Art, Youngstown, Ohio; The Reading Art Gallery, Reading, Pennsylvania; The New Britain Museum of American Art, New Britain, Connecticut; The Norfolk Museum of Fine Arts, Norfolk, Virginia; The W. B. Connor Foundation, Danbury, Connecticut; Columbia University, New York; Adelphi College, New York, and the University of Maine.

Mr. Pellew currently lives in Norwalk, Connecticut.